Islamic
Art IN DETAIL

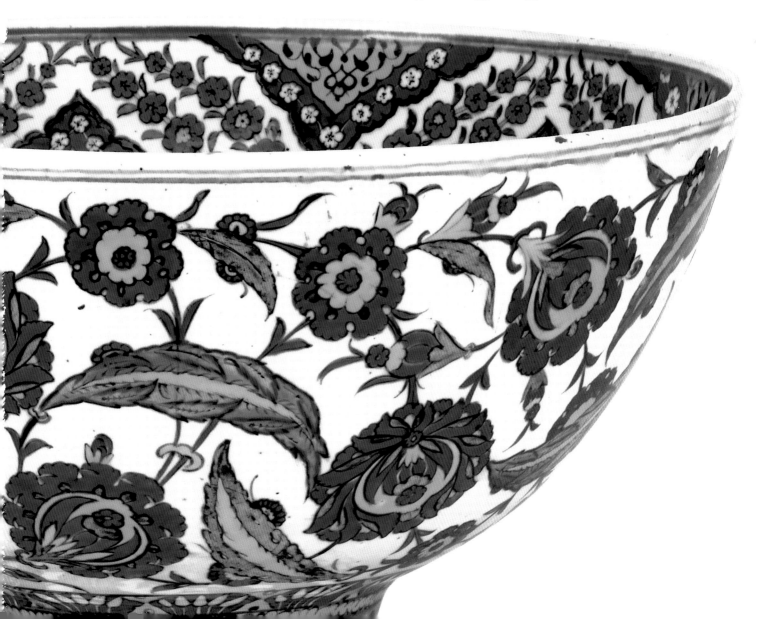

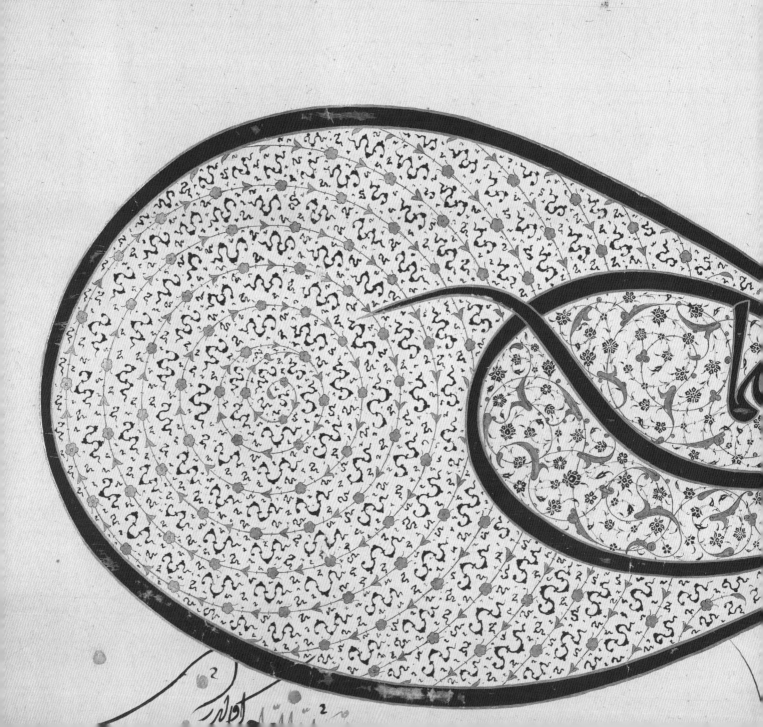

Islamic Art IN DETAIL

Sheila R. Canby

THE BRITISH MUSEUM PRESS

HALF-TITLE PAGE: Large footed Iznik ceramic bowl, Ottoman Turkey, c. 1545–50 (see p. 82).

TITLE PAGES: Tughra of the Ottoman sultan Suleyman the Magnificent (r. 1520–66) (see p. 15).

RIGHT: Detail of Ottoman decoupage illustration, late 16th century (see p. 72).

Photography by the British Museum Department of Photography and Imaging (John Williams and Kevin Lovelock)

First published in 2005 by The British Museum Press
A division of The British Museum Company Ltd
38 Russell Square, London WC1B 3QQ
www.britishmuseum.co.uk

Sheila R. Canby has asserted her moral right to be identified as the author of this work

A catalogue record for this book is available from the British Library

ISBN-13: 978-0-7141-2428-5

ISBN-10: 0-7141-2428-1

Designed and typeset in Minion and Helvetica by Harry Green

Printed in China by C&C Offset Printing Co., Ltd

Contents

Preface

How do we know, as soon as we cross the threshold of a museum gallery, that it contains Islamic art? What tells us the artefacts are products of the Muslim world, a culture that has historically extended from Spain to Southeast Asia?

The purpose of this book is to examine those elements and themes that enable us to define art forms as Islamic, despite their broad historical range – from AD 622 to the present day – and wide geographic spread: North Africa, the Middle East, Central Asia and parts of South and Southeast Asia, not to mention areas of recent conversion across the globe. Surely one cannot expect the art of 9th-century Iraq to resemble that of 19th-century north India, yet the Arabic script, arabesque and geometric design recur in the arts of these and other Islamic lands, reinterpreted with each successive era and in every region.

One of the common myths about Islamic art is that it is characterized by a horror vacui or fear of emptiness, leading to an unwillingness to leave any surface blank or undecorated. Although this is an exaggeration and overgeneralization, the surfaces of many Islamic objects are substantially covered in ornament, often small-scale and combining several types of decoration. Whereas in museum galleries or photographs one may only be able to see a single side of a highly decorated object, in this book we can examine its hidden details and begin to understand more fully its style, technique and iconographic programme. Furthermore, by identifying the themes illustrated on a variety of different objects, we can start to appreciate the preoccupations of the cultures in which these pieces were made.

Like the idea of horror vacui, the notion that figural imagery is prohibited in Islamic art is widespread. Nowhere does the Qur'an, the Muslim holy book, state that the representation of humans or animals is forbidden. Rather it is the Hadith, or Traditions of the Prophet Muhammad, which refers to this proscription. The human image never appears in copies of the Qur'an, which is the literal word of God and thus canonical: it cannot be altered. Animal and human forms are absent from religious architecture such as mosques and madrasas, with extremely rare exceptions. Yet on objects made for secular and domestic

use, books of science, history and poetry, textiles, and palaces and city gates animal and human imagery abounds.

The types of human, animal and vegetal ornament found in Islamic art provide a window on to the environment and concerns of the people for whom it was made. Pleasurable pastimes such as hunting, drinking, music-making and dancing are depicted on many objects. Signs of the zodiac and symbols for the sun and the moon suggest a fascination with the heavens, while animals, real and imaginary, are ubiquitous in Islamic art. Nature is also present, usually without any narrative or iconographic implication. At certain times, artists and craftsmen in the Islamic world depicted Christians or other non-Muslims. Likewise, spiritual advisors played a significant role at many Islamic courts, and artists were commissioned to portray these figures.

The objects illustrated in this book all come from the collection of the British Museum. Carpets, textiles and costumes, and of course large architectural items, are absent from the collection and thus are not included here, although they are important aspects of Islamic art. This book is organized thematically, permitting details of objects from a variety of geographic sources and periods to be juxtaposed. Rather like a meal of Middle Eastern mezze, this book is intended to encourage the reader to sample the variety of images on offer. Rather than emphasizing art-historical issues, the aim is to communicate the wonder of holding an Islamic ceramic bowl or inlaid metal ewer, or examining a miniature painting under magnification. The virtuosity and imagination of the artists who created these treasures cannot be overestimated. The pieces illustrated here were produced primarily for the enjoyment of their owners, a pleasure we can continue to experience unabated to this day.

NOTE The dimensions of the objects illustrated in this book and their British Museum registration numbers are given on page 142.

1

What is Islamic art?

The works illustrated here were produced against a highly complex backdrop of history. Islamic art encompasses lands of desert, mountains, swamps and steppe. The plethora of dynasties that ruled these territories can confuse the most clear-headed historian, and the frequency of wars, rebellions, invasions and civil strife may give the impression that the lives of artists and their patrons were anything but peaceful. Yet, despite the seeming chaos, and even in periods of political disintegration, artists created works of superlative, innovative design decorated with inscriptions and motifs whose message was positive and auspicious.

Just as we might assume that an object decorated with Chinese or Japanese characters comes from East Asia, so the presence of Arabic script denotes a connection with the lands in which the religion of Islam is predominant. Arabic is revered by Muslims as the language of the Qur'an, the Muslim holy book: its text is the word of God as transmitted to the Prophet Muhammad, and is thus immutable. Only the shapes of its letters can change. Muhammad received God's revelation in the early 7th century. Since his death in AD 632, after which

the words were written down, the 28-letter Arabic alphabet has been used by Arabic speakers across North Africa and the Middle East. Other languages of the region such as Persian, Turkish and Urdu also came to be written in Arabic letters, with additional letters created to represent the extra sounds found in those languages. Because of the flexibility of Arabic letter-forms and the apparent desire of early Muslims to distinguish their culture from those of the peoples they conquered, the decorative properties of the Arabic script were appreciated and exploited from the beginning of the Islamic era onwards.

In addition to Arabic writing, a type of vine scroll called the arabesque is a mainstay of Islamic design. Developed from the Late Antique scroll and acanthus leaf decoration of the Eastern Mediterranean regions once controlled by the Romans, the arabesque acquired its own distinctive forms in Islamic times. Based on the convolvulus (bindweed), the defining characteristic of the arabesque is the infinite 'return' of the vine, combined with the varied forms of its flowers and leaves, in pairs, either split or whole. Arabesque

decoration appears in the gold illumination surrounding the chapter (*sura*) headings in the earliest Qur'ans. As its name in English implies, the arabesque is a form of abstract ornament identified with the Arab world, although in fact it can be found in Islamic art from Spain to Southeast Asia from the 10th century to the present. Decorative rather than representational, the arabesque can be combined with geometric, epigraphic and figural elements and often forms only one of several levels of decoration on objects as disparate as inlaid metalwork and carpets. Its use adds to the complexity of Islamic design by providing rhythm and visual continuity to a whole range of media.

The third primary element is geometry. While geometric ornament can be found in Roman and Late Antique mosaics and textiles, it attains a much more dominant role in Islamic design. Star shapes and polygons appear in all the arts and provide a source of much architectural decoration. Simple knots adorn writing as well as arabesque scrolls. Like Arabic script and the arabesque, geometric shapes are highly versatile and can be extremely complicated.

Humans and animals also play a significant role in the decorative vocabulary of Islamic art. Their uses run the gamut from specific narrative functions to standard forms of decoration. For instance, 8th-century palaces in Syria and Jordan contain wall paintings and relief sculptures of human figures and floor mosaics of animals. Often these are framed by bands of vegetation or placed in a stylized landscape setting. While some of these representations of humans and animals possess iconographic meaning, even if it is not well understood today, others appear to have served solely decorative purposes. This duality runs through the history of Islamic art, even after the growth in production of illustrated manuscripts from the 13th century onwards. Animal and human forms were sometimes combined in inscriptions with Arabic letter-forms or with the vines and leaves of arabesque scrolls, where they are most often used as purely ornamental devices.

Detail of the base of a Mina'i ware bowl, Iran, signed by Abu Zayd, dated AH 583/ AD 1187–8. Ceramic stonepaste body with underglaze and overglaze decoration and transparent colourless glaze. The bisymmetrical arabesque springs from a central stalk.

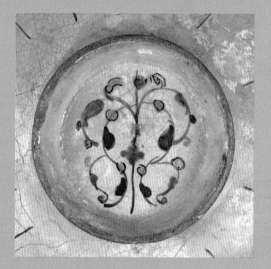

Arabic script

Even in the 7th century, the form of the Arabic script depended on its use. Squared and highly stylized letter shapes were employed in early Qur'ans and on coins in a script called kufic. Although this style of writing was eventually superseded by scripts with rounded letters for the copying of Qur'ans, it continued to be used for inscriptions in stone on buildings and tombstones, on wooden panels and in chapter headings of books, as well as on portable objects. As an archaic and monumental form of writing, kufic has retained a gravitas and architectonic quality with appropriate uses across the spectrum of Islamic art.

The Arabic alphabet has 28 letters based on 17 shapes which are differentiated by dots placed above or below them. In early inscriptions on buildings, such as the Dome of the Rock from AD 691–2, or on coins of the late 7th century, the basic letter-forms of Arabic were used without dots above or below the letters. Over time the dots were added to avoid confusion, and the use of script with rounded letter-forms increased. The script is read from right to left, which naturally affects the flow of the cursive letters. As with the Latin or Roman alphabet, styles of Arabic script developed in response to particular needs, such as rapid writing for informal personal use and elegant rounded scripts for copying manuscripts.

By the 10th century Islam had spread to the west as far as Spain and in the east to Central Asia and the Indus river, making it necessary to standardize the rounded styles of Arabic script. A minister at the ᶜAbbasid court in Baghdad who was also a celebrated calligrapher, Muhammad ibn Muqla (d. AD 940), and his follower Ibn

Detail of a cartouche from an ᶜalam (standard), Iran, late 17th century. Gilded brass with openwork inscriptions and floral decoration.
Jaᶜfar and Musa, the names of two of the 12 Shiᶜa imams (divinely guided leaders), are inscribed here embedded in a flowering arabesque. The elongation of letters in each name provides balance across the cartouche.

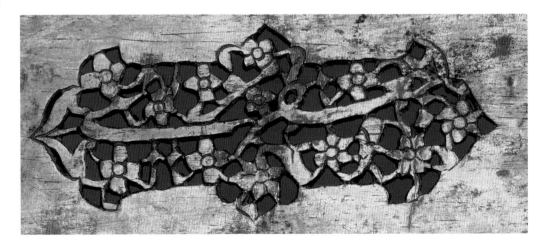

Page of poetry in nasta^cliq script, Mughal India. Copied in Burhanpur, dated AH 1140/AD 1630–31.
Written on the diagonal, the elegant nasta^cliq or hanging script is perfectly suited to the rhyming hemistiches of Persian poetry. The poem expresses the Sufi desire to approach God and achieve oneness with Him in paradise. The erasure at the bottom of the page may have contained the name of Prince Dara Shikoh, who lived at Burhanpur in 1630 with his mother Mumtaz Mahal and was murdered in 1659 at the behest of his brother Aurangzeb.

Bawwab (d. 1022), defined six styles of cursive writing based on a strict system of proportion. In the first instance, these styles – naskh, thuluth, muhaqqaq, raihan, tawqi^c and riqa^c – were intended to match the beauty of kufic and thus be suitable for copying the Qur'an. The basic unit of the system is the rhombus – the equilateral, oblique-angled dot used above and below letters. Multiples of this figure, when lined up point to point, determine the height and width of each letter in each of the six styles.

According to legend, the scribe Mir ^cAli al-Sultani (*c.* 1340–1420), who worked for two grandsons of Timur (Tamerlane) at Tabriz, in northwest Iran, had a dream of flying geese and was directed by ^cAli, son-in-law of the Prophet Muhammad and the fourth caliph, to imitate their shapes in a form of writing. This led to Mir ^cAli's invention of a new script, nasta'liq. This 'hanging script' was well suited to the copying of Persian poetry, especially rhyming couplets, because of the emphasis on certain letters as a result of their diagonal elongation. Although very rarely used for copying Qur'ans, nasta'liq became the dominant writing style in Iran from the 15th century onwards.

The issuing of official documents presented the governments of the later Muslim empires of Ottoman Turkey, Safavid Iran and Mughal India with the opportunity to develop special forms of writing and monograms. One of the most striking of these is the tughra, the individualized

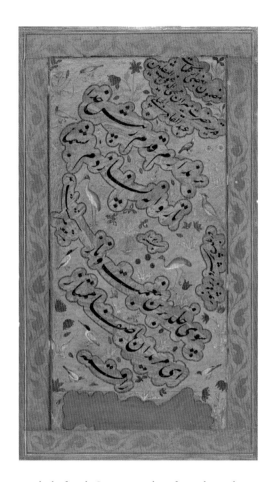

symbol of each Ottoman sultan from the 14th century onwards. The device consists of letters forming the name of the sultan, with their loops extending to the left and elongated vertical extensions thrusting upwards. The tughra exemplifies the adaptability of Arabic letters, which has enabled artists of all media to combine the script with vegetal, geometric, zoomorphic and anthropomorphic elements yet maintain the legibility of the inscription.

Details from the border of a Qur'an, Iran and India(?), 14th century. Ink, opaque watercolour and gold on paper. Right: The phrase 'alaihi al-salam', 'peace be upon him' from the Hadith (Traditions of the Prophet), is written in kufic script, an archaic style after the 13th century. The Hadith inscription may be later than the Qur'anic text.

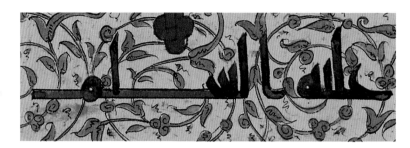

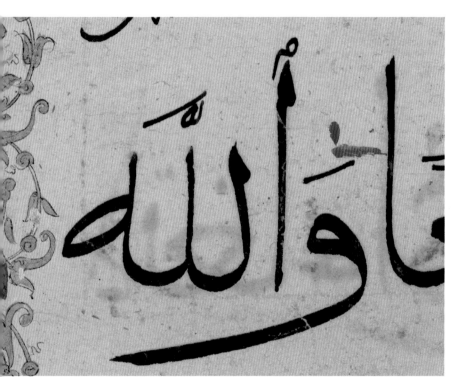

Left: The majestic muhaqqaq script in which these words – 'wa Allah', 'and God' – are copied is one of the six styles of writing perfected by the 13th-century calligrapher Yaᶜqut in Baghdad. From the late 13th to the 15th century this was the preferred script for scribes copying the Qur'an. The contrast between the elongation of the alif, the first letter of the Arabic alphabet, and the flatness of the letters ending below the line imparts a rhythm deemed well suited to the copying of Qur'ans.

Signature from a brass penbox inlaid with silver and gold, Iran, dated AH 680 /AD 1281.
The inscription in naskh, one of the six styles of cursive writing, states that Mahmud ibn Sunqur made the penbox in AH 680 /AD 1281. The tiny signature was inscribed on the side of the penbox, underneath the clasp.

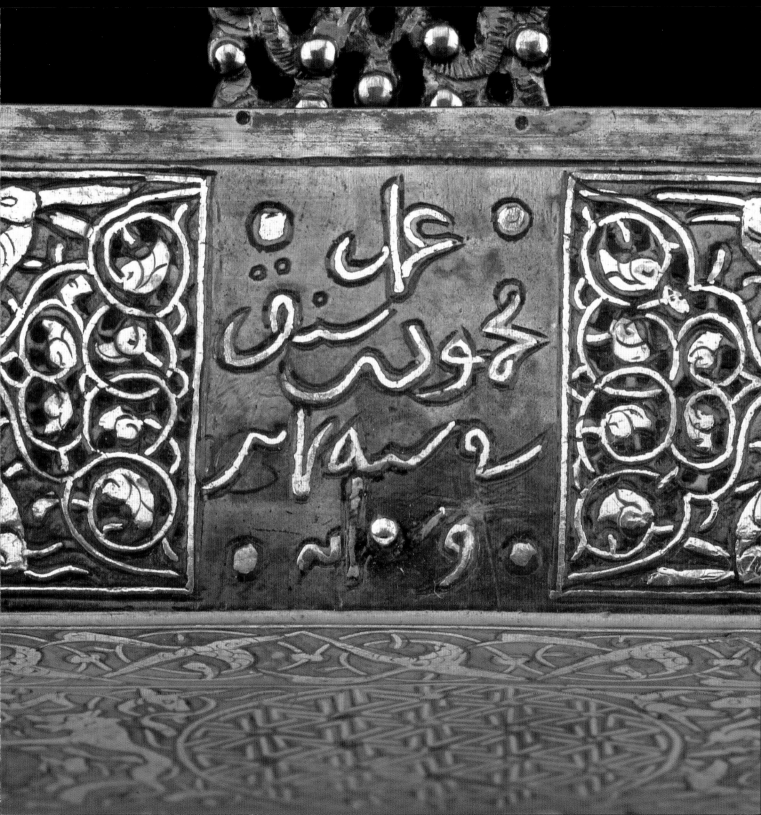

**Detail from the tughra of Sultan
Suleyman the Magnificent.**
Tughras were placed at the head of official Ottoman
documents and letters. This writing, outside of the
emblem itself, is in divani script, a style specifically
used by scribes within the court administration.

**Tughra of Sultan Suleyman the Magnificent
(r. 1520–66), Ottoman Turkey, mid-16th century.
Opaque watercolour and gold on paper.**
From the 14th century onwards, each Ottoman
sultan had an individualized monogram called
a tughra, consisting of the names of the ruler
and his ancestors at the foot of three tall shafts,
with two ovals extending to the left.

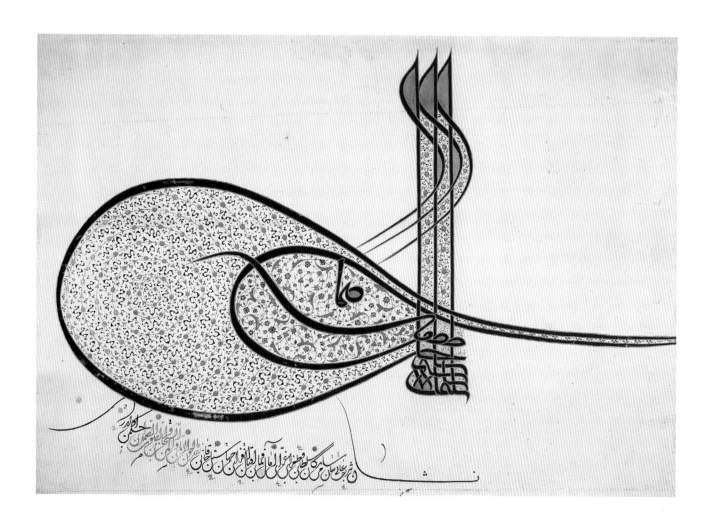

Detail of a Mina'i ware bowl, Iran, signed by
Abu Zayd, dated AH 583 /AD 1187–8.
Ceramic stonepaste body with underglaze
and overglaze decoration and transparent
colourless glaze.

The two inscriptions visible below consist of
a rapidly written naskh band inside the rim
and a kufic inscription of repeating good wishes.
Many examples of this twice-fired luxury ware
of the late 12th century feature royal imagery
combined with inscriptions.

Details of the neck and side of the 'Blacas' ewer, northern Iraq, Mosul, dated AH 629/ AD 1232. Brass inlaid with silver and copper. The name of Shujaᶜ bin Manᶜa al-Mawsili, neatly inscribed in naskh, appears on the faceted neck of this ewer (left). The name, date and place named on the piece provided the key information that enabled scholars to identify the 13th-century school of Mosul metalworkers. Near the base of the ewer are words of blessings – 'well-being, health, gravity' – in kufic script with exaggerated vertical letters (above), alternating with roundels containing two versions of the fret design characteristic of Mosul metalwork of this period.

Tombstone of Jalal al-Din ͨAli in the shape of a mihrab (prayer niche), Iran, Kashan, 13th–14th century. Ceramic tiles with moulded and applied decoration, cobalt and opaque white glaze and lustre overglaze.
These tiles would have been the inner portion of a much larger composition including the death date of the deceased and elaborate decorative panels. The inscription within and below the trefoil-shaped arch consists of the names of seven generations of qadis (judges) from whom the deceased was descended. Framing the centre is a verse from Sura 2 of the Qur'an. All the inscriptions are written in thuluth, a cursive script well suited to monumental use.

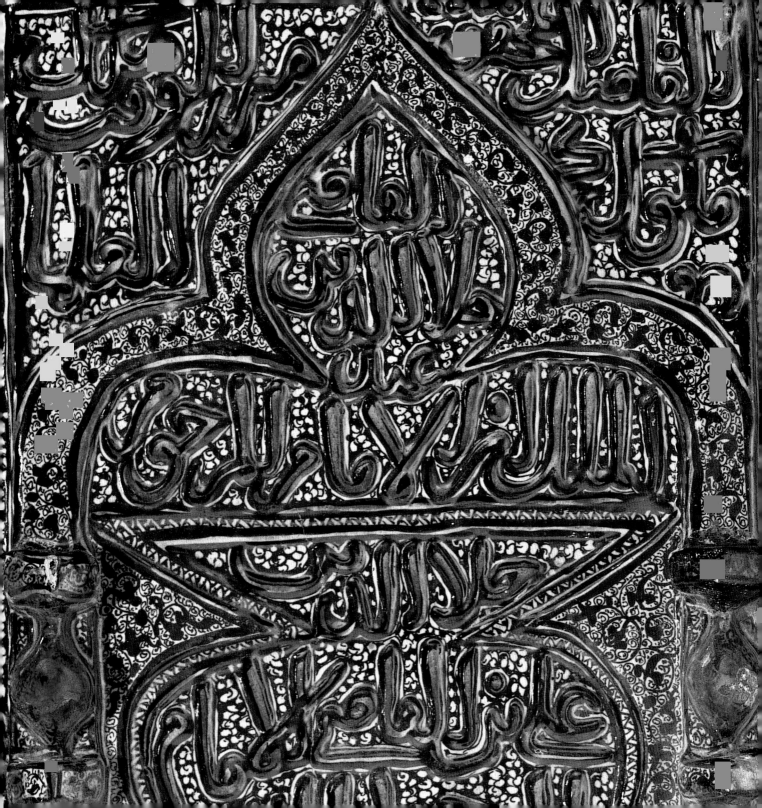

Geometry

Geometry lies at the heart of Islamic design. Just as the rhombic dot is the basic unit for determining the proportions of Arabic letters, so the forms of plane geometry – circles, triangles, quadrilaterals and polygons, and their segments – underpin the nonfigural decoration of both objects and structures in Islamic art and architecture. From the simple polygons and rectangles used as framing devices to the highly complex interlaces of stars and irregular polygons, geometry functions as an organizing principle on the surfaces of the whole range of media.

Geometry has precedents in the Late Antique and Byzantine art of the Eastern Mediterranean and North Africa. What distinguishes geometric ornament in Islamic art from its predecessors is both its emphasis and its great formal variety. Whereas lozenges or bands of the Greek key motif, for example, are found in many pre-Islamic contexts, such forms were either adapted and changed beyond recognition or embellished with additional decoration in Islamic art.

As with many other decorative motifs in Islamic art, the incidence of geometry grew during the 7th and 8th centuries, and from the 9th century onwards it was a standard feature of Islamic ornament. The reasons for the firm establishment of geometry as one of the dominant types of Islamic ornament are not entirely clear. However, the intellectual environment at the courts of the ʿAbbasid caliphs from the 9th to the 11th century may have played a role in generating an interest in mathematics which extended far beyond the confines of the court itself. During the reign of Harun al-Rashid (r. 786–809), the caliph immortalized in the *Thousand and One Nights*, several of the treatises of Euclid were translated, and within two decades of Harun al-Rashid's death al-Khwarazmi had explained the decimal system and 'founded' modern algebra at the House of Wisdom in Baghdad. The excitement surrounding al-Khwarazmi's work led to further developments in mathematics and geometry in the 10th and 11th centuries, including more translations of Greek sources and the continued exploration of Indian mathematical systems. These new ideas found practical applications, particularly in the computation of the division of estates and in the use of arithmetic by government bureaucrats. Until the mid-10th century, people had computed by mental arithmetic or by writing numbers on a board covered with sand. The whole approach to computation changed, however, after a manuscript written in the mid-10th century explained how to use the newly adopted medium of paper and pen for calculations.

Because the utility of such advances was

grasped across early medieval Islamic society, it is not surprising that artists wished to apply the new ideas to their creations. As so much geometric ornament on Islamic objects demonstrates, the transformation from one shape into another (such as 8-pointed stars to octagons) suggests the mathematical equivalent of word-play. Moreover, the implication of infinity found in the interlace of polygons extending out from a central star echoes debates of the 9th and 10th centuries concerning infinite numbers. Even when the intellectual climate changed in the 12th and 13th centuries, artists continued to decorate their work with geometric motifs, so embedded was the idea of its appropriateness in Islamic art.

While vegetal, zoomorphic or epigraphic elements are often enclosed within geometric forms, some regions and periods emphasized geometry over other types of ornament. Thus the 13th- to 15th-century madrasas (religious colleges) of Merinid Morocco and most of the15th-century Nasrid rooms of the Alhambra are enveloped in a an abundance of tiled, wooden and stucco geometric patterns. Some of these contain vegetal motifs and some frame inscriptions on a ground of vegetation, but the main impression is of almost dizzying geometric pattern on every surface. During the same period, Egyptian and Syrian manuscript illuminators and woodworkers also explored the possibilities of uninterrupted geometric patterns, while metalworkers, glassmakers and potters favoured

encircling their wares with large inscriptions and bands of vegetal decoration.

Further east, in Iraq, Iran and Afghanistan, long-standing traditions of human and animal imagery maintained their vigour, but intricate geometric designs serve as frames and filler elements on many metal and ceramic objects of the 12th to 14th centuries. Following on from the taste for minute geometric designs on metalwork and manuscript illumination in 15th-century Iran and Central Asia, the interest in geometry receded and the dominant decorative styles of Ottoman Turkey, Egypt and the Levant, Safavid Iran, Uzbek Central Asia and Mughal India focused on floral and vegetal motifs. Yet even vine scrolls on later Islamic objects appear to depend on systems of proportions and underlying shapes that are essentially geometric.

Octagon detail from the 'Blacas' ewer, northern Iraq, Mosul, signed Shuja^c bin Man^ca, dated AH 629/ AD 1232. Brass inlaid with silver and copper. Octagons and circles containing inlaid silver whorls or fretwork placed at the centre of each facet punctuate the bands of epigraphic and figural decoration on this ewer.

**Infinite knot details from a Qur'an, Iran and India(?),
14th century. Ink, opaque watercolour and gold on paper.**
The intersection of red lines at the centre of the knot below forms
a rhombus which is embellished by the angled loops above and
below and tear-shaped extensions on the left and right.

Centred on a small black square, the intersecting
light brown lines below form a cross on the
cardinal points and a larger one on the diagonal,
enclosing four simple cartouches. A quatrefoil
consisting of four half-circles intersects the
diagonal cross.

**Detail from 'Farid observes a drunken scene',
Dastan-i Amir Hamza, Mughal India, *c.* 1562–79.
Opaque watercolour and gold on paper.**
This dome, tiled with inscribed gold and green
six-pointed stars and red hexagons, is a fanciful
interpretation of geometric architectural
ornament. Such tiles are more often employed
on walls than on domes, and in Mughal India
most domes were not tiled at all.

Details from 'Farid observes a drunken scene',
*Dastan-i Amir Hamza***, Mughal India, *c.* 1562–79.**
Opaque watercolour and gold on paper.
The latticework of these two windows consists of
octagons and squares on the left and hexagons on
the right. Each polygon is bisected by horizontal
and vertical lines.

The flowers and vines in the interior and lobing
of its outline above add interest to a basic
ellipse. Such motifs appear as central medallions
in bookbindings and carpets.

The head of the large mace is decorated with
an eight-pointed star with radiating outlines that
encompass irregular hexagons and octagons
before resolving in more stars.

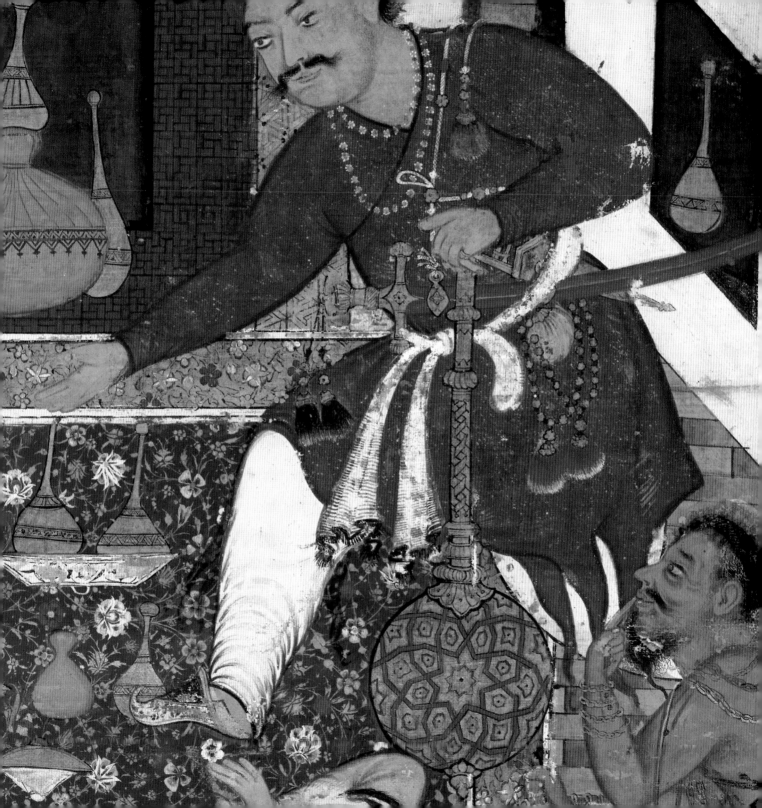

The arabesque

Like geometric ornament, the arabesque – a scroll with repeating and reciprocating leaf and floral elements attached to a vine – serves as a framing and filler device in Islamic art. Developing from Late Antique acanthus and vine scrolls, the arabesque is characterized by its rhythmic undulation. Like some geometric ornament, the arabesque can imply an infinite design with no defined beginning or end. Additionally, the reciprocal course of the vine in an arabesque is more geometric than natural. One of the contributing factors to the infinite pattern of the arabesque is the growth of leaves, flowers or other motifs from one another rather than from a single stem.

As a frame for other elements of a composition, the arabesque may be simple and repetitive, confined to a narrow band between larger design components such as an inscription or figural vignette. As a filler, the arabesque can extend into the interstices of any composition. In other instances, the arabesque can play a major role on its own and become the focus of the decoration. A special attribute of the arabesque is its remarkable versatility both in form and function, which has contributed to its longevity in Islamic art.

Various scholars have pointed out that the vegetal elements comprising the arabesque were not exclusive to Islamic art. However, its uses and geographical distribution are unique to the Islamic world, which was united politically for several centuries after the death of Muhammad and by religion for far longer. The trade and exchange of ideas from Spain to Central Asia and beyond ensured the spread of particular types of ornament, such as the arabesque. As with geometry in early Islamic art, the disengagement of the arabesque from its Late Antique predecessors took place gradually but becomes increasingly evident from the 10th century onwards. The strict adherence to symmetry begins to abate, and the vines and leaves entwine or break out of their geometric frame.

The simplest arabesques consist of a stem from which split palmette leaves spring. By the 11th century, however, the use of arabesques had extended to embellishing inscriptions and filling spaces between compositional elements of all kinds. The evolution of combining arabesques and writing may have begun with the so-called floriated and foliated kufic letters found in various media, from Yemeni textiles to Nishapur ceramics, in the 10th century. While these floral and vegetal motifs enhanced the vertical letters of kufic inscriptions, they remained attached to the letters and superimposed above the inscriptions. However, by detaching the vegetal or floral flourish from individual letters, the calligrapher could write an inscription that rested on top of

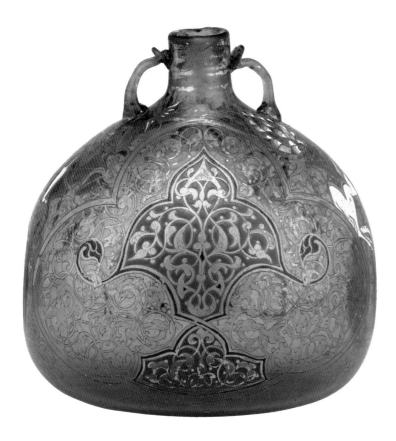

Pilgrim bottle, Syria, 1340–60. Gilded and enamelled glass.
Two forms of arabesque cover the rounded side of this bottle. Two interlaced trefoils contain a symmetrical, highly formal arabesque. Around this is a spiralling vine whose tendrils terminate in animal and human heads.

the arabesque, either literally or figuratively depending on the medium. Almost as in music, the arabesque behind an inscription provides rhythm without overwhelming the main calligraphic motif. By the 16th century, Persian court weavers were using one or more arabesques to cover the fields of carpets in which a central medallion and hunting scenes were the primary theme. In this context, the arabesque suggests depth while enhancing the tempo of the overall design.

By the 12th century, arabesques no longer consisted only of stems and leaves or flowers. Animal and human heads began to appear in place of leaves. This development parallels the introduction of human-headed or human-shaped letters in epigraphy, particularly that found on metalwork from Afghanistan and then from Mosul in northern Iraq. However, whereas the fashion for such 'animated' writing declined, the use of arabesques with human and animal heads continued into the 17th century, perhaps because they were a stylization of the waq-waq tree, the talking tree of Arab and Persian literature. Frequently appearing in literature about the wonders of the world, waq-waq trees are related to a tree mentioned in the Qur'an on which demons' heads grew instead of fruit. Although arabesques with animal and human heads did not illustrate such stories, they would have been created in the same spirit of wonderment at the exotic creatures thought to exist just beyond the limits of the known world.

To an even greater extent than Arabic letters or geometric forms, the arabesque offered artists limitless opportunities for adaptation and reinvention across the Islamic world. For example, following the Mongol conquests of the 13th century, traditional Chinese cloud scrolls and wave patterns entered the visual vocabulary of artists from Central Asia to Egypt, who merged these forms with arabesques. Thus the arabesque, which appears on all media, reflects the artistic styles of successive cultural interactions and developments.

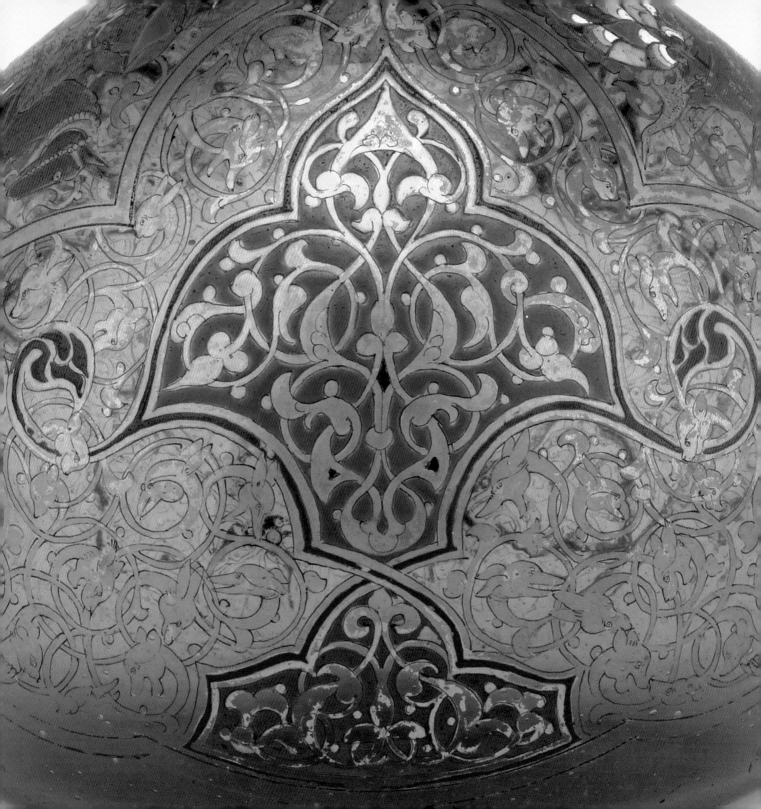

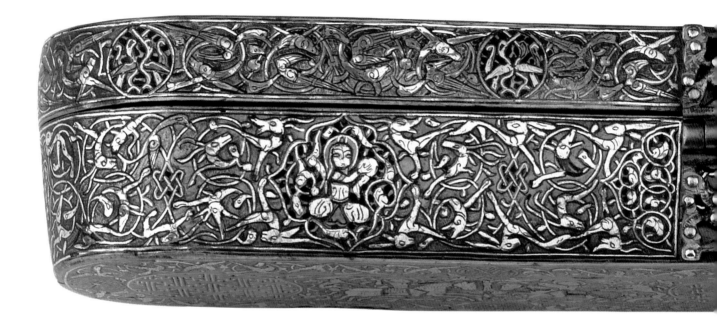

Pilgrim bottle, Syria, 1340–60.
Gilded and enamelled glass.

A close-up view of the central arabesque (left) reveals that the glassmaker has scratched veins into the leaves and has added three small red touches, echoing the red enamel of the border and 'wings' that curl out to either side. The intertwining of the vine suggests an arabesque on two levels, with no starting or ending point. Surrounding the central trefoils, the spirals of an inhabited scroll endow it with a rhythm matched by the lively animal-, bird- and human-headed 'leaves' in this arabesque. A particularly charming feature is the animals' heads that curl over the 'wings' of the central panel.

Penbox, western Iran, signed by
Mahmud ibn Sunqur,
dated AH 680/AD 1281.
Cast brass inlaid with silver
and gold.

As in the glass pilgrim bottle (left), the arabesque on the sides of this penbox consists of animals and birds instead of leaves. Also, each section of the arabesque springs from a central knot based on a rhombus.

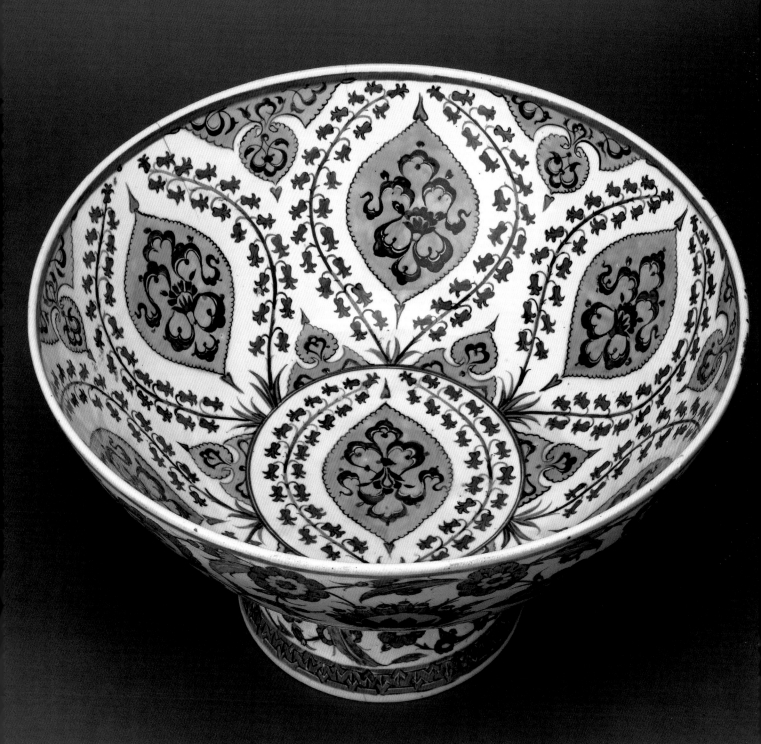

Left: Large footed bowl, Ottoman Turkey, Iznik, *c.* 1545–50. Ceramic stonepaste body, turquoise, blue, black and green underglaze and transparent colourless glaze.

The interior of this magnificent Iznik bowl contains seven turquoise lobed ellipses enclosing black cloud bands. This motif, resembling floating ribbons, is related to the arabesque but does not share all of its characteristics. Derived from Chinese ornament, the cloud band consists of two sets of three trilobed forms springing from a central flower. Unlike arabesques, the cloud bands are not infinite. However, some cloud bands – such as those in pendants along the inner rim of the bowl – terminate in split palmette leaves as commonly found in arabesques.

Right: Detail of a large footed bowl, Ottoman Turkey, Iznik, *c.* 1545–50. Ceramic stonepaste body, turquoise, blue, black and green underglaze and transparent colourless glaze.

Although the ornament in the ellipse on the right closely resembles that in the bowl on the left, it is actually a different large footed bowl and is a true arabesque, with tendrils and split palmette leaves.

The human figure

'Prince Khurram weighed against gold, silver and other metals', from a dispersed *Jahangirnama***, Mughal India,** *c.* **1618. Opaque watercolour, ink and gold on paper.** Portraiture in Mughal India under Emperor Jahangir incorporated European techniques and an openness to producing likenesses of the royal family and high court officials.

The Qur'an, the Muslim holy book, does not explicitly forbid the representation of the human form, although it does say that God alone creates, giving life to man and beast, and that He rejects idols. In the Traditions of the Prophet Muhammad, or Hadith, composed of sayings attributed to Muhammad, a variety of negative references can be found to the makers of images. Ironically, these sayings are contradicted by others, which refer to possessions of Muhammad that were adorned with human figures. Thus the Hadith appear to provide justifications for both sides of the question.

The limited amount of material from the 7th century that can be identified as having been made for or by the first Muslims is not particularly helpful for the understanding of early Islamic attitudes towards the portrayal of humans. Religious structures such as the Dome of the Rock (AD 691–2) do not contain human imagery, and its inscriptions refer to the superiority of Islam over Christianity. By extension, this may validate the exclusion of the human form from the Muslim religious setting as a rejection of the distracting or seductive properties of Christian depictions of the Holy Family. For coinage, the Muslims first relied on reusing Byzantine and Sasanian coins, which both employed human representations, but in 695–7 the coinage was reformed and inscriptions replaced figures. Thus, in two of the most public official manifestations of Islam, religious architecture and coins, the human form was absent.

In the private world of the early Muslims, however, the representation of humans and animals continued unabated. Wall paintings in Syrian and Jordanian palaces, metal objects with figures in relief and stucco heads on fortress walls all attest to the taste for adorning princely spaces and possessions with human figures. By the 10th century, examples of human figures are found in the decorative arts of Iraq, Syria, Iran, Spain and Egypt. Zoomorphic images of the constellations appear in scientific manuscripts of the 11th century and, 200 years later, on celestial globes. By the 12th century, with increased production of glazed ceramics in Egypt, Syria and Iran, bowls and other items decorated with human imagery were widely available. Nonetheless, these are outnumbered by pottery without figural decoration, so presumably both tastes existed side by side.

With a few rare exceptions, none of the early or medieval Islamic representations of humans could be considered portraits. Rather, most of the figures follow a standard iconography related to courtly life and astrological or astronomical personifications. While illustrations in late 12th- and early 13th-century manuscripts depict the protagonists so that they can be identified, there is

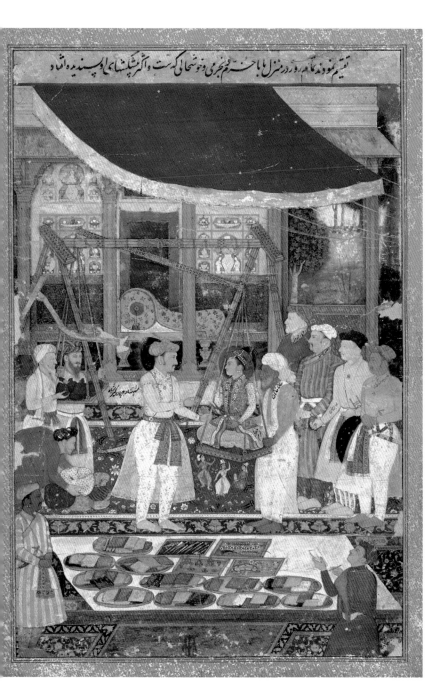

no indication that these figures were intended as likenesses of actual people. Even 'portraits' of authors and patrons in the frontispieces of Arab and Persian 13th-century manuscripts are idealized; artists did not attempt to depict figures three-dimensionally in Islamic painting until the late 16th century, when they were exposed to European painting techniques. Instead, the influence of China by way of the Mongols in the 13th and 14th centuries and the Timurids in the 15th century reinforced the traditional two-dimensional, bird's-eye view of figures on painted surfaces.

Despite this emphasis on the schematic function of human figures, Timurid princes and kings such as Baysunghur in the 1420s and Sultan Husayn Bayqara in the 1480s apparently ordered likenesses of themselves for frontispieces and album pages. Depictions of 16th-century Safavid rulers may have been inserted into paintings illustrating episodes in the narrative of manuscripts. Without the techniques of illusion, how did people recognize figures in portraits? We must assume that girth, pose and attributes, such as jewellery or articles of clothing, were sufficiently specific to the sitter. In 17th-century Mughal India, painters combined elements of Persian and indigenous Indian painting with European illusionism to produce more naturalistic images of men, although women retained their idealization, as if their modesty were preserved by not portraying them three-dimensionally.

Mina'i ware bowl, Iran,
signed by Abu Zayd,
dated AH 583/AD 1187–8.
Ceramic stonepaste
body with underglaze
and overglaze decoration
and transparent
colourless glaze.
During the century
preceding the Mongol
invasion of Iran in 1220,
the figural style found on
ceramics and in one
surviving manuscript
favoured 'moon-faced
beauties' of both sexes –
round-faced figures with
narrow, elongated eyes.

Detail of the cover of the 'Vaso Vescovali',
Iran or Afghanistan, Khurasan province, c. 1200.
High tin bronze, engraved and inlaid with silver.
The sun, depicted above as a disc with three faces above a plank
supported by an angel between two figures, plays either a
benevolent or malevolent role in Islamic astrology, depending on
the proximity of the other planets.

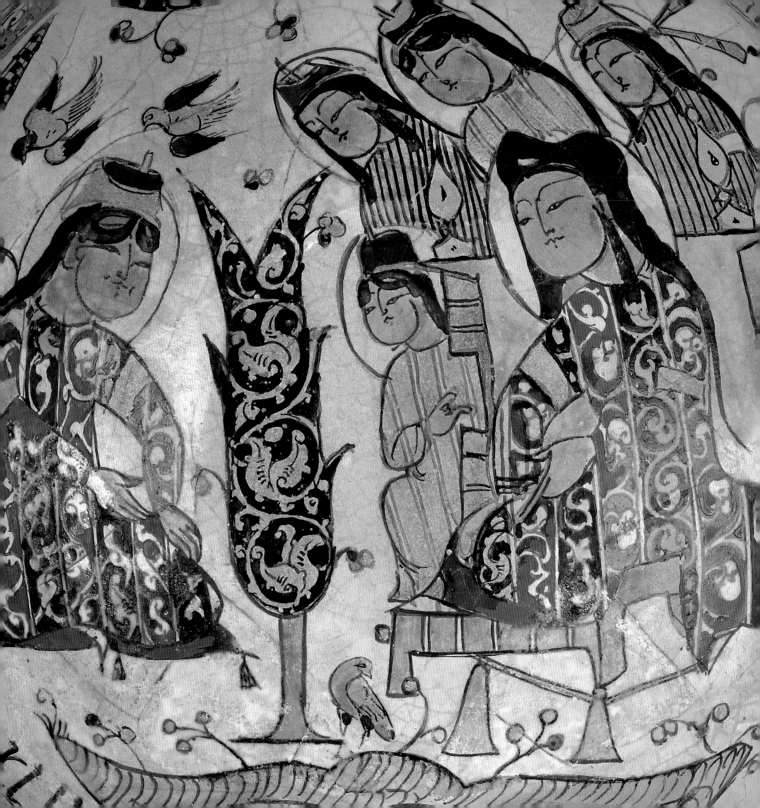

Portrait of Shah ᶜAbbas I, Mughal India, attributed to Bishn Das, *c.* 1619. Opaque watercolour and gold on paper.
The meeting in Iran between Shah ᶜAbbas I and Khan ᶜAlam, the Mughal ambassador, was recorded by the Indian artist Bishn Das and the Persian Riza-yi ᶜAbbasi. Bishn Das produced several preparatory portraits in which he depicts Shah ᶜAbbas as small and insignificant. Here Bishn Das has emphasized the Shah's small stature by showing him in an undefined space with large amounts of green around him and by lengthening his waist and making his legs seem short.

Right: This close-up view of the head of Shah ᶜAbbas reveals the corrections made by the artist Bishn Das to the figure's left eye and in the areas left and right of his head, where the darker green brush strokes are visible.

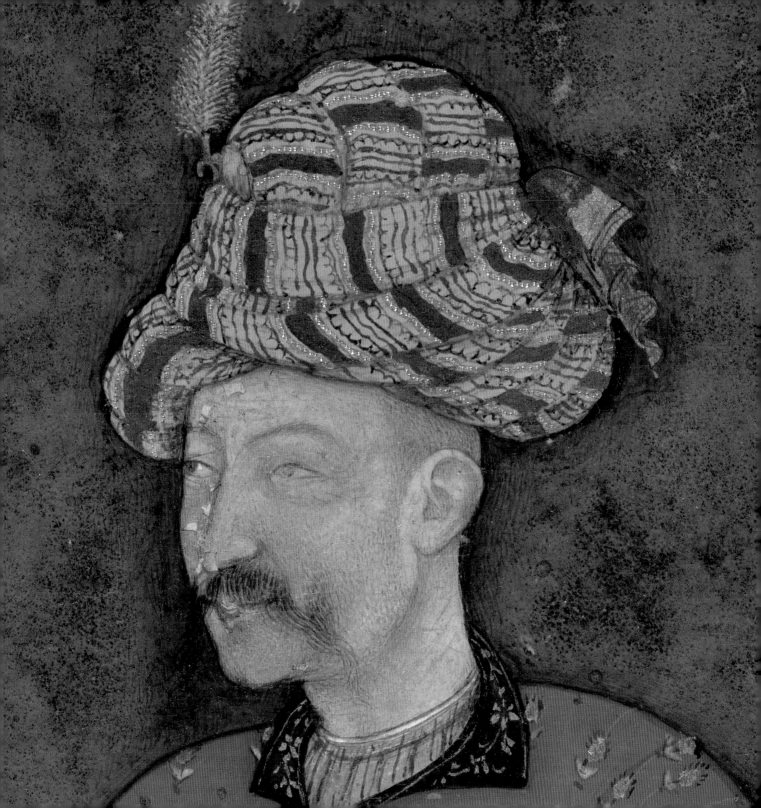

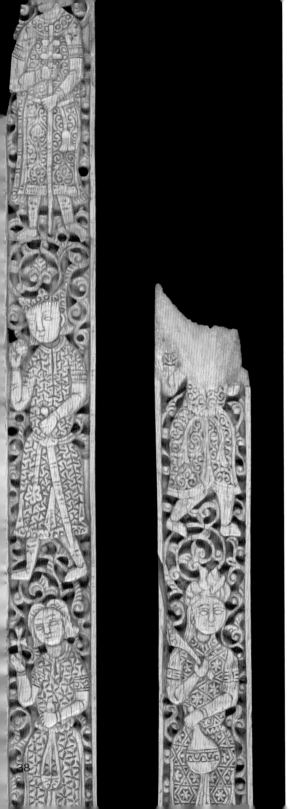

Two carved ivory panels, Mamluk Egypt, 14th century.
Although the faces of these figures closely resemble each other, their garments and attributes differentiate them. The patterns of their robes vary, ranging from flowers enclosed in hexagons at lower right to intersected lozenges at lower left, and leaf and vine designs. Portrayed in diverse poses, the figures stand or walk while holding objects such as a sword, a cross and a bottle. The cross suggests that these panels were used in a Christian context, perhaps framing the cover of a Bible.

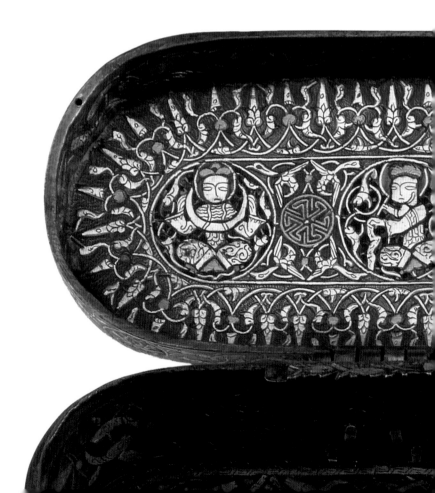

Detail of the inside lid of a penbox, brass inlaid with silver and gold. Iran, signed by Mahmud ibn Sunqur, dated AH **680/**AD **1281.** Six of the seven planets are shown here in roundels on the interior lid of the penbox. All but the sun, a round face surrounded by rays, is rendered in human form. From left to right the planets are the moon, who holds a crescent before him; Mercury, whose pen is poised over the scroll in his left hand; Venus, playing a lute; the Sun; Mars with a sword and severed head; and Jupiter, who is bearded and holds a bottle.

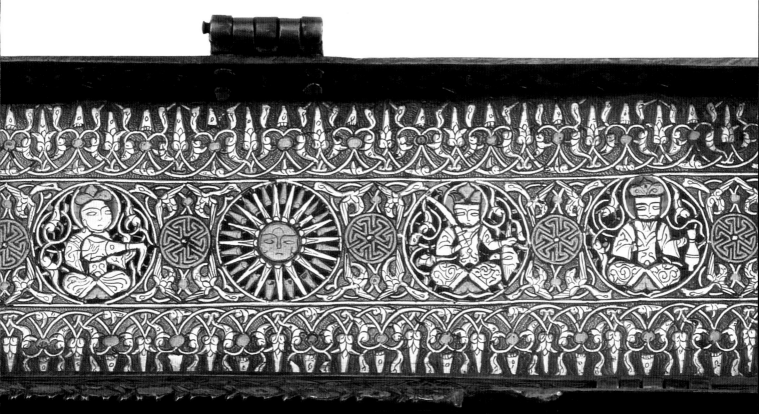

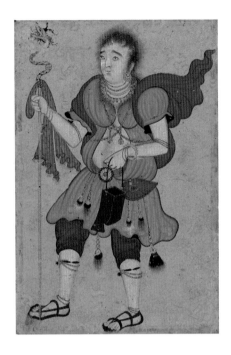

More than in other Islamic schools of painting, Mughal artists sought to depict figures naturalistically and incorporated European illusionistic techniques, such as modelling of forms. This is achieved on the face of the dervish (right) through the shading both under his chin and between his right eye and his nose. In this detail, the contrast is evident between the impassive, staring eyes and pursed lips of the dervish and his swirling, unruly hair and eyebrows. Such figures fascinated Emperor Akbar (r. 1556–1605), who welcomed discussions with mystics of all faiths.

Dervish, Mughal India, *c*. 1570–80.
Opaque watercolour and gold on paper.
This strangely clad, blue-eyed mendicant is bedecked with feather amulets and bells, intended to protect him from evil. The dragon-headed staff would also have had a talismanic function, while the dervish would have collected alms in his square bucket.

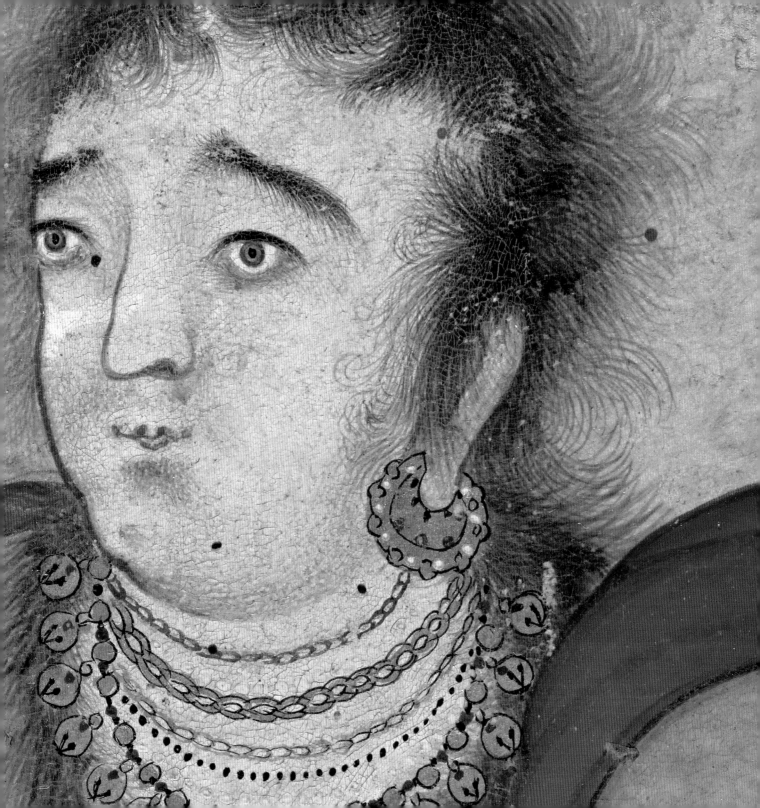

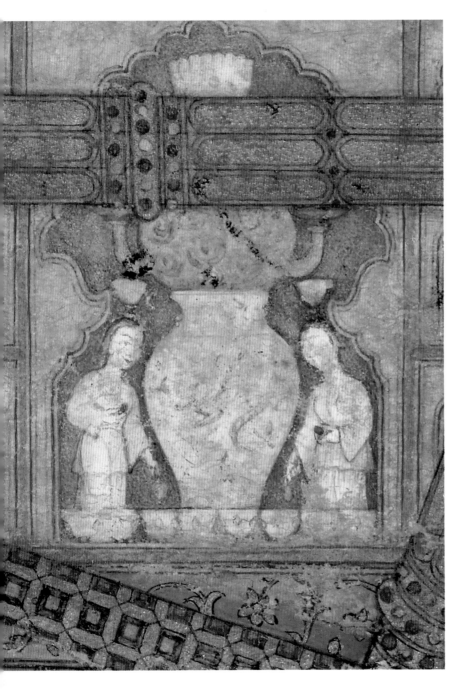

Details from 'Prince Khurram weighed against gold, silver and other metals', from a dispersed *Jahangirnama*, **Mughal India, *c*. 1618. Opaque watercolour, ink and gold on paper.**

Left: This detail, of a small collection of Chinese porcelain placed in a niche, includes two standing figures of women holding fruit or other objects. These closely resemble blue and white porcelain ewers of the Wanli period (1573–1620), which could have been exported to India.

Below: This detail shows the main motif in the central medallion of a carpet laid below the scale, with two dancing girls, their arms raised, and a tambourine player. They appear to support Prince Khurram while he is suspended in the air.

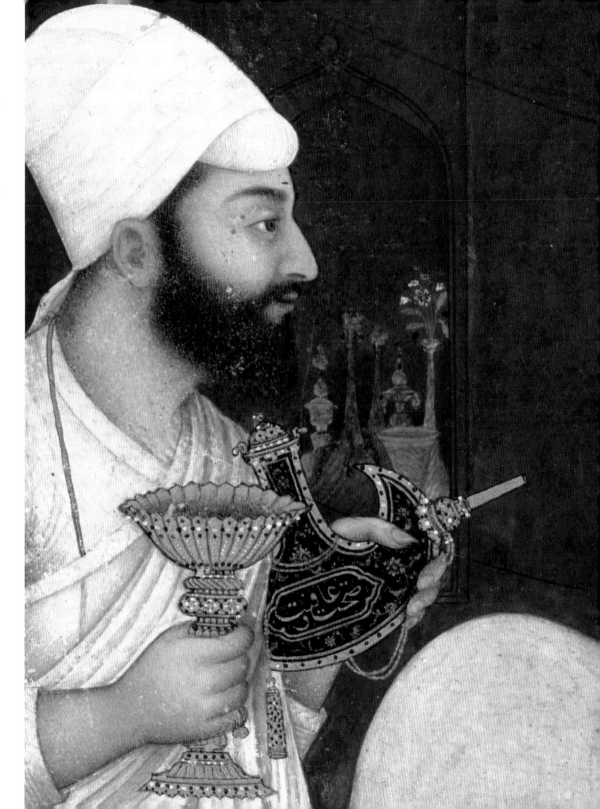

Detail of 'Ibrahim ᶜAdil Shah venerates a learned sufi', India, Deccan, Bijapur, signed by ᶜAli Riza, c. 1620–30. Opaque watercolour and gold on paper. Ibrahim ᶜAdil Shah II (r. 1579–1627) was a remarkable patron of art, music and poetry and presided over a flowering of the Bijapur school of painting. His mystical leanings and syncretic approach to religion resulted in a mixture of Hindu and Muslim imagery in his writings. Here the artist has captured Ibrahim's hopeful yet calm visage. The rounded volumes of his face and turban and his pink lips suggest health, a condition echoed in the inscription on the flask that he offers to the sufi shaykh, meaning 'health and well-being'.

2

Religion and belief

During the second decade of the 7th century, an Arab from Mecca named Muhammad began to experience revelations which he came to understand were the word of God. The essential message of this revelation was that there is one God and Muhammad is his messenger. Within the context of 7th-century Mecca, a pilgrimage centre for polytheists, Muhammad's preachings were a threat to the established system of beliefs and way of life. As he gathered followers he also made enemies so that in AD 622, following the deaths of his wife and the uncle who had protected him, Muhammad left Mecca and re-established himself and his followers in Yathrib, later renamed Madina. With this migration, called the Hijra, the Islamic calendar begins. During the next ten years, until his death in 632, Muhammad preached God's revelation. This included laying down the 'five pillars of Islam': bearing witness that 'there is no god but Allah, and Muhammad is his messenger'; prayer in the direction of the Ka'ba in Mecca five times a day; fasting and refraining from sex between sunrise and sunset during the month of Ramadan; zakat or almsgiving; and performance of the Hajj, the pilgrimage to Mecca, at least once in a believer's life.

Following the death of Muhammad, his successors oversaw the copying of his revelation so that, by the mid-7th century, the Qur'an existed in book form. As already mentioned, the Qur'an is the literal word of God and cannot be altered. Because of its prime importance and the reverence in which it is held by the Muslim faithful, the Qur'an has been the focus of artistic attention from the beginning. Since the text of the Qur'an is never illustrated, the creative energy expended on producing Qur'ans was directed at writing beautiful letters and embellishing the chapter headings and other divisional markers with illumination in gold and other colours. Likewise mosques and madrasas (Muslim religious colleges) were adorned with non-figural ornament and inscriptions in tiles, mosaic, wood, stucco, stone and paint.

The early Muslims believed their mission was to spread the word of Islam, which means 'submission to God'. Within a century of Muhammad's death, the faith had spread through conquest and conversion as far west as Tours in France and eastwards to Transoxania (modern Uzbekistan). The Byzantine empire receded to Constantinople while western and northern

Testament figures such as Noah and Moses who, although Jewish, are also accepted as prophets by Muslims. By the 15th century Muhammad and ꜥAli, his cousin and son-in-law, and the founder of the Shiꜥa sect of Islam, were portrayed with veiled faces. Images of people praying in mosques, of imams leading the faithful in prayer, and of Muhammad and his human-headed horse Buraq on their Night Journey to heaven all entered the pictorial repertoire.

After the Mughal conquest of India in 1526 and the foundation of the Mughal school of painting around 1555, Hindu and Muslim artists worked together and formed a new hybrid style with its roots in Persian, Hindu, Jain and European painting. Emperor Akbar (r. 1556–1605) commissioned translations of Hindu epics and married Hindu women. He and his successor, Jahangir, shared a sincere interest in religion and Sufism, the mystical form of Islam. Dervishes became a popular subject for paintings in Mughal North India as well as in the sultanates of the Deccan, the south central region of India. Some of these states remained independent of the Mughals until the late 17th century and retained a distinctive atmosphere in which the arts, literature and philosophy all thrived. With the growth of trade in the 17th century between Europe and Turkey, Iran and India, Western travellers commissioned albums containing pictures of local figures including members of the Muslim hierarchy.

Double-page opening of a Qur'an, Iran and India(?), 14th century. Ink, opaque watercolour and gold on paper. The verses on these two pages come from Chapter 5 of the Qur'an. They concern the unacceptability of the Christian concept of the holy trinity, which for Muslims contradicts the oneness of God.

Anatolia and the Persian Sasanian empire fell to the Muslims. Yet Christianity, Zoroastrianism and Judaism did not disappear from the conquered regions, and the Crusaders' occupation of parts of the Levant in the 12th century contributed to an increase in Christian imagery on metalwork and other media. Ironically, before the Mongol conquest, images of Christians are more recognizable than are those of Muslims practising their religion, either through attributes such as the cross or because of their European dress.

In the 14th century the Mongols commissioned illustrated manuscripts in which the story of Muhammad and the early Muslim conquests was depicted. These included pictures of Old

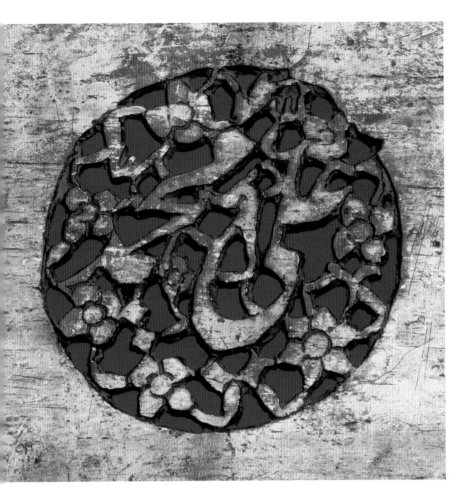

Roundel from an ᶜalam (standard), Iran, late 17th century. Gilded brass with openwork inscriptions and floral decoration.

This openwork roundel contains the names of ᶜAli and Muhammad. To Shiᶜa Muslims, Muhammad and ᶜAli are the most important figures in Islam. Muhammad is the Prophet of God and ᶜAli – his cousin, son-in-law and third successor – is the first in the hereditary line of imams, the divinely guided leaders of the Shiᶜat ᶜAli (Party of ᶜAli). After Shiism was established as the state religion in Iran under the Safavids (1501–1722), many metal objects were inscribed with the names of Muhammad, his daughter Fatima and the 12 imams.

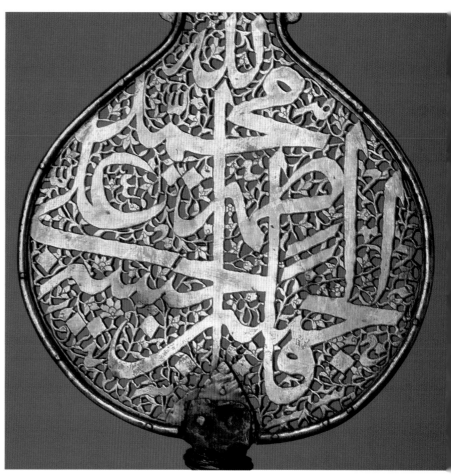

This standard would have been affixed to the top of a pole and carried in a procession, possibly at Muharram, when the martyrdom of Husayn (the son of ᶜAli) is commemorated. Its shaft symbolizes the sword of ᶜAli and its openwork decoration contains the names of the 12 imams. In the large roundel at the base of the shaft are the names 'God, Muhammad, Fatima [Muhammad's daughter, and wife of ᶜAli], ᶜAli, Hasan and Husayn'. Between the two stylized wings a smaller roundel contains the phrase 'Ay [oh], ᶜAli'.

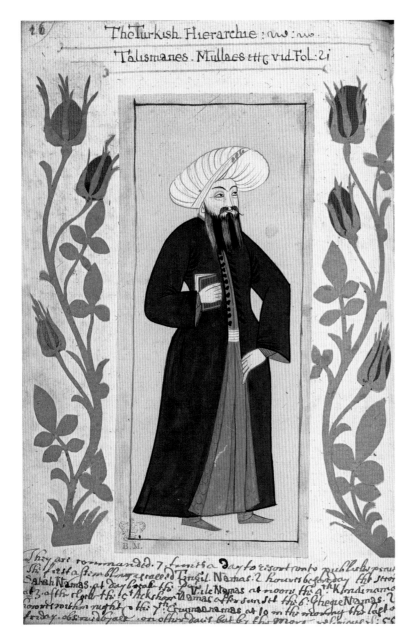

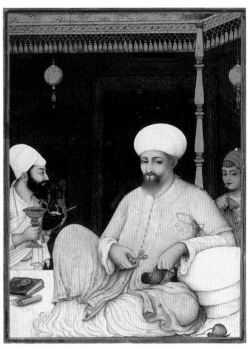

Left: 'A Mulla', from *A briefe relation of the Turckes, their kings, Emperors, or Grandsigneurs, their conquests, religion, customes, habbits, etc*, Ottoman Turkey, *c.* 1618. Opaque watercolour on paper, with cut-out roses in margins.

This picture of a Mulla, a Muslim cleric, comes from an album compiled for Peter Mundy, an English traveller to Istanbul, in 1618.

Above and right: 'Ibrahim ᶜAdil Shah venerates a learned Sufi', India, Deccan, Bijapur, signed by ᶜAli Riza, *c.* 1620–30. Opaque watercolour and gold on paper.

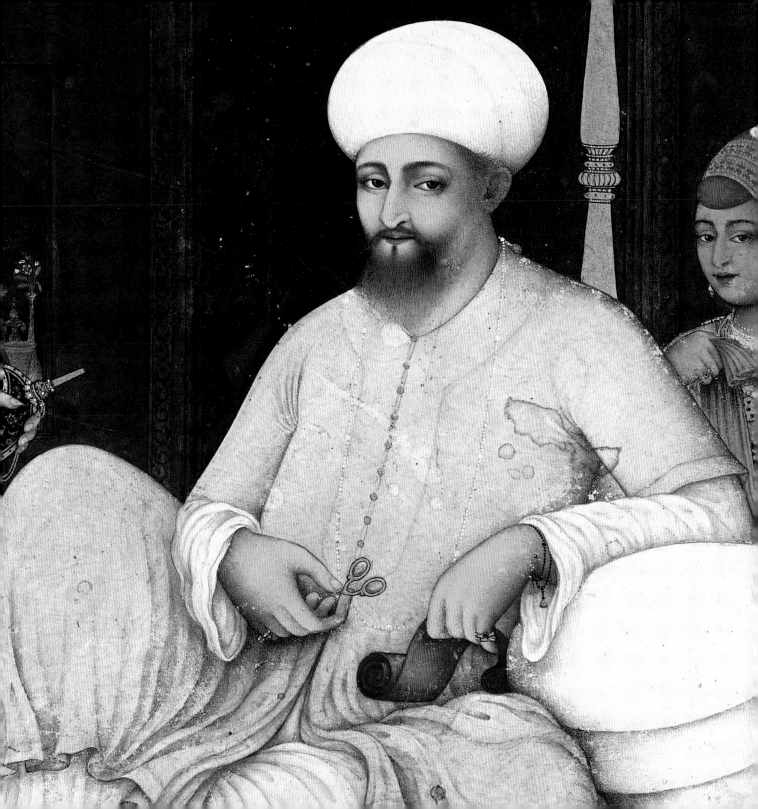

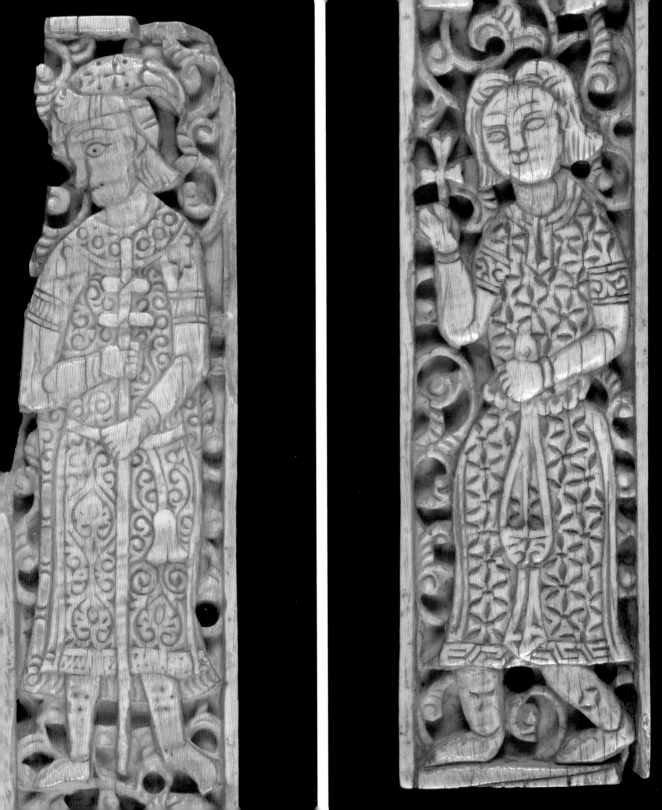

Details of two carved ivory panels, Mamluk Egypt, 14th century.

These two figures not only hold crosses but the headdress of the figure on the left is also decorated with a cross. Such depictions indicate that Christians were still a sizable proportion of the Egyptian population during Mamluk times.

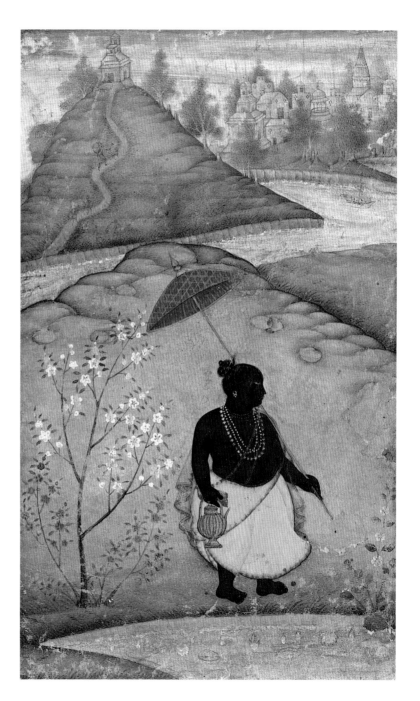

Vamana, the dwarf incarnation of Vishnu, Mughal India, *c.* 1610. Opaque watercolour and gold on paper.

Mughal artists depicted Hindus and Hindu religious and narrative subjects such as Vamana, the fifth avatar of Vishnu. Here the artist has incorporated the standard iconography of Vamana, depicting him as a dwarf holding a parasol and a water pot, which he is about to fill. He asks a king for as much land as he can cover in three steps, then transforms himself into a giant whose three steps cover the earth and heavens. Despite the Hindu subject, the style of the painting – with a cityscape in the background and atmospheric treatment of the landscape – conforms to the Mughal court style.

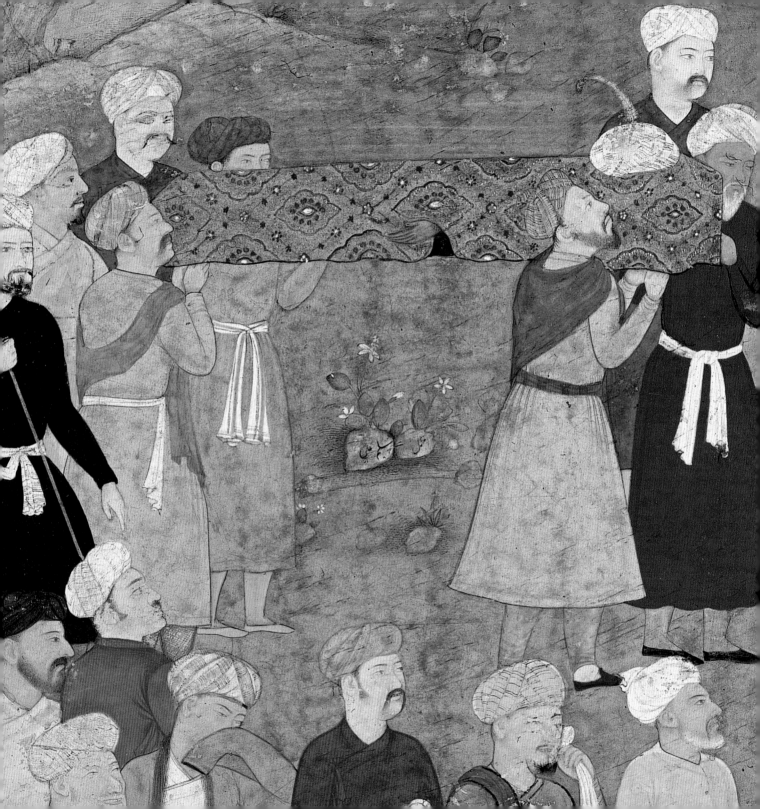

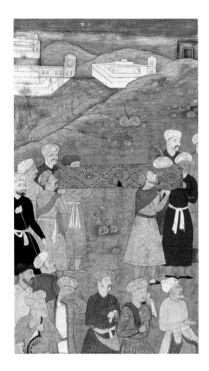

'The funeral of Iskandar' mounted as an album page, Mughal India, signed by Salim Quli, *c*. 1620. Opaque watercolour and gold on paper.

This painting, said to represent the funeral of Iskandar (Alexander the Great), presents the subject as if it were a Muslim interment. Iskandar features in the *Shahnameh* (Book of Kings), the Persian national epic, and the *Khamseh* of Nizami, both of which were illustrated in Mughal India. Traditionally, Muslims wash the body of the deceased and place it in an open coffin draped with a cloth, which in this painting appears to be an Ottoman Turkish brocade.

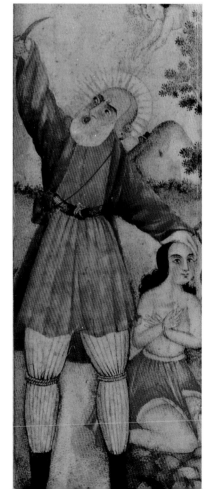

Penbox, Qajar Iran, 2nd half of the 19th century. Lacquer over pasteboard.

The eclectic imagery of Qajar penboxes includes many vignettes based on European print sources. On the top of this box, Abraham holds a dagger in the air as he prepares to sacrifice his son Isaac. Above him a host of angels hover around a larger angel who intervenes, while two figures dressed as monks remonstrate at the feet of Abraham. Although their stories differ somewhat, the three 'religions of the book' – Islam, Christianity and Judaism – all consider Abraham a crucial prophet.

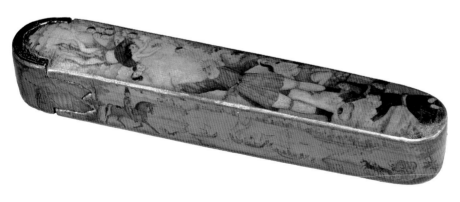

3

The supernatural world

A belief in spirits, fantastic creatures and prognostication is by no means limited to the Islamic world. People have perennially devised systems or created beings to explain the unexplainable in order to deal with a whole range of experiences that cannot otherwise be understood. While astrology, for instance, may be viewed by some today as pseudo-science, it was taken very seriously in the pre-modern Islamic world, where it was considered an adjunct to astronomy. Dragons, unicorns, centaurs, harpies and sphinxes adorn Islamic objects and architecture, and although their precise meaning may not always be clear, many appear in contexts in which they seem to be warding off evil. Djinns, or genies, have a more destructive role and are considered the source of a great deal of trouble, but they can also sometimes be helpful. Their forms may vary, but in some cases djinns are shown as demons.

As with mathematics, knowledge of astrology passed to the Islamic world from the ancient Greeks, Persians and Indians. It consisted of two branches: natural astrology, which was concerned with observing the influence of the stars on nature, and judicial astrology, which related to

their influence on the fate of humanity. The study of astrology required some knowledge of astronomy, although originally astronomy probably grew out of astrology. Natural astrology focused on the rising and setting of certain stars, making weather predictions based on the positions of stars, and noting atmospheric conditions on certain important days. A body of literature arose, consisting of tables listing the stars' movements and agriculture information in almanac form. Judicial astrology had two main functions: deciphering auguries from the position of the stars at the time of a person's birth, and predicting auspicious and inauspicious times.

In the early and medieval Islamic eras, seven planets were known: Jupiter, Venus, the moon, Saturn, Mars, the sun and Mercury. The first three were considered benign, the fourth and fifth were seen as negative, and the last two varied according to their relationship to the other planets. In addition, astrologers believed in the existence of two pseudo-planets, corresponding to the head and tail of a dragon and symbolizing the lunar eclipse. Within five degrees above and below the orbit of the sun lay 12 constellations, which formed the 12 signs of the zodiac.

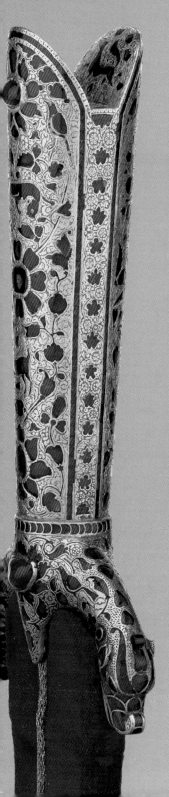

Astrological predictions were based on the relationships of the zodiacal signs to the planets at specific points in time. A predictive system of great antiquity first elucidated in Arabic in the 9th century, astrology and its symbols have retained their importance in the Islamic world into the modern era. The frequent appearance on metal and ceramic wares of symbols representing the zodiac and the planets, as well as extant horoscopes drawn up for 15th- and 16th-century princes, provide evidence of the abiding reliance on astrology and its predictions.

Sphinxes and harpies are ubiquitous in Persian art of the 12th and 13th centuries but do not tend to appear in literature aside from the genre of 'wonders of creation'. Dragons, on the other hand, feature strongly in astrology, literature and art. Until the early 14th century, Islamic dragons were depicted looking more like fat snakes with ears and curling snouts than as the undulating,

Hilt of a dagger, Mughal India, c. 1625. Gold inlaid with rubies and emeralds, steel blade, velvet over wooden sheath.
The quillon (cross bar) of the hilt terminates in the heads of two dragons with curled-up snouts. These derive from the Indian makara, a dragon-like mythical creature more closely related to the crocodile than to the Chinese or European concept of a dragon.

scaly beasts with flaming shoulders that inhabit the post-Mongol world. Likewise, the ancient Iranian senmurv, a beast with a lion's head and a bird's tail, was transformed into a simurgh, a phoenix-like bird, after the Mongol conquest in the 13th century. Although both the dragon and the simurgh had already enjoyed a long life in Persian literature, after the 14th century their shapes were derived from Chinese prototypes imported into the Middle East by the Mongols. While dragons are usually malevolent in a narrative context, they also appear on city gates, thrones and glazed tiles, where they would have served to protect the people within. In literature, simurghs are generally benevolent and magical, whereas detached from the narrative setting they often appear in combat with dragons in carpets and bookbindings or alone on ceramics and glass. Again, despite the absence of a precise iconographic significance, it is clear that simurghs represent auspiciousness and power.

In Islam, djinn are described as created from flame; although they are inherently immaterial, they can take many forms. They appear in the Qur'an as the helpers of Solomon and are depicted in manuscript illustrations and 19th-century lacquer wares as demons surrounding Solomon's throne. Unlike djinn, an Arabian creation, *div*s (demons) personify evil in Persian myth. Their ghoulish forms are perennial favourites in illustrated manuscripts of the *Shahnameh*, the Persian national epic.

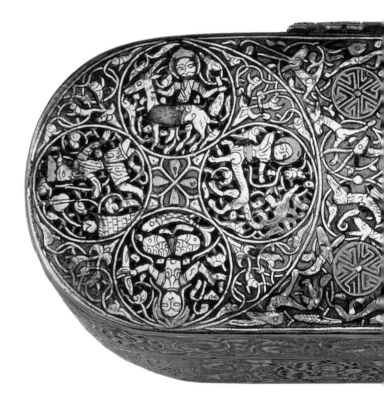

**Left: Detail from 'Rustam sleeping while Rakhsh fights the lion',
from a dispersed, unfinished *Shahnameh*, Iran, Tabriz, attributed to
Sultan Muhammad, *c.* 1515.**

By the early 16th century, the convention of depicting concealed faces in
rocks had been in use for over a hundred years. The green, pink and blue
rocks enclose ghoulish visages with flattened noses, along with a lion.
While they may represent the spirits inhabiting the meadow around the lion's
lair in which Rustam sleeps, they may also be interpreted as djinns, which
in Persian painting are often portrayed with the features of demons.

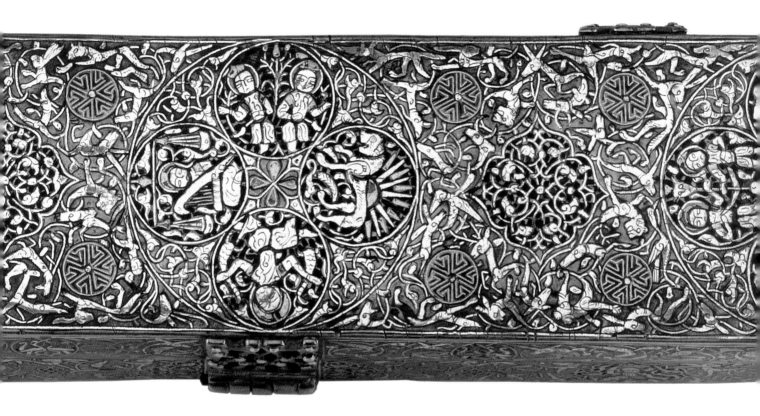

Lid of penbox, western Iran, signed by Mahmud ibn Sunqur, dated AH 680/AD 1281. Cast brass inlaid with silver and gold.
The twelve signs of the zodiac are arranged in three roundels on the outer lid of the penbox. Each sign is combined with the symbol or personification of its planet-lord. Thus the sun rises behind Leo at the right of the centre roundel and Venus plays the harp under the scales of Libra to the left in the same roundel. Combined with the personifications of the planets on the interior of the same penbox, this astrological imagery would have had been a potent symbol of universal order.

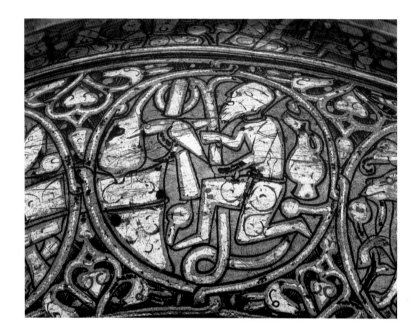

Right: Detail of the marginal decoration from a dispersed album of poetry, Timurid Iran, Shiraz, mid 15th century. Ink and gold on paper.
These figures with their wings, legs terminating in vines, and leafy caps can be identified as peris, or fairies. Peris had magical properties and could also marry humans, though here they are simply benignly decorative.

Below: Detail of Taurus from the 'Vaso Vescovali'.
The planet Venus plays the lute while riding the astrological sign Taurus, the bull. The crescent at the upper right represents the moon, and the dragon head below the bull refers to the dragon-monster that swallows (eclipses) the moon.

Above: Detail of Aquarius from the 'Vaso Vescovali', lidded bowl, Iran or Afghanistan, Khurasan province, _c._ 1200. High-tin bronze inlaid with silver.
The twelve signs of the zodiac appear around the sides of this footed bowl. Here the bearded figure pulling water from the well personifies both the water-carrier Aquarius and his planet-lord Saturn.

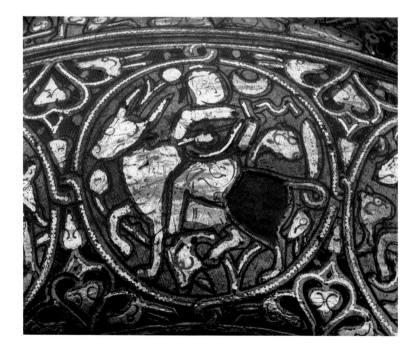

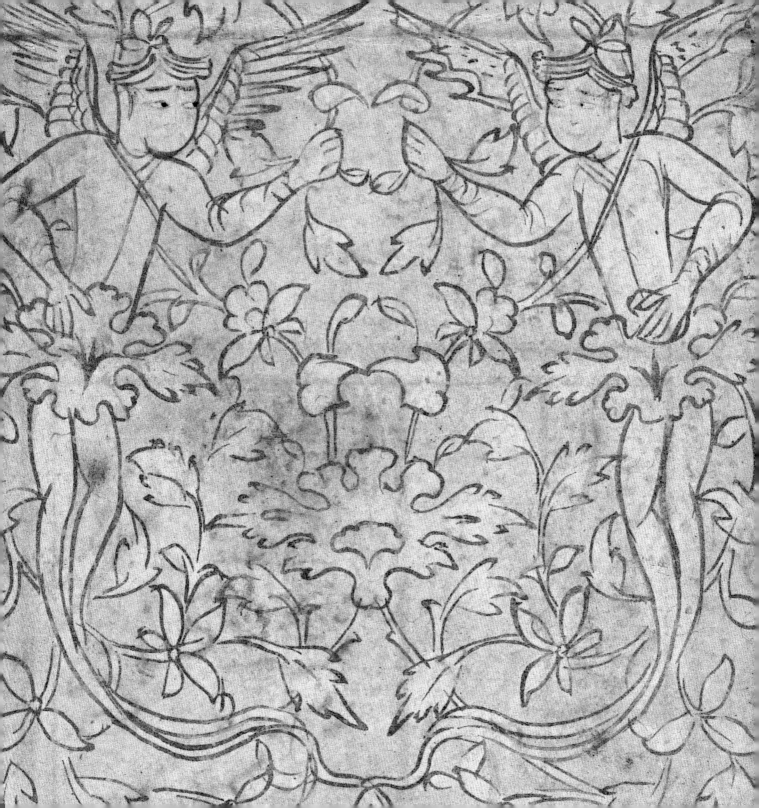

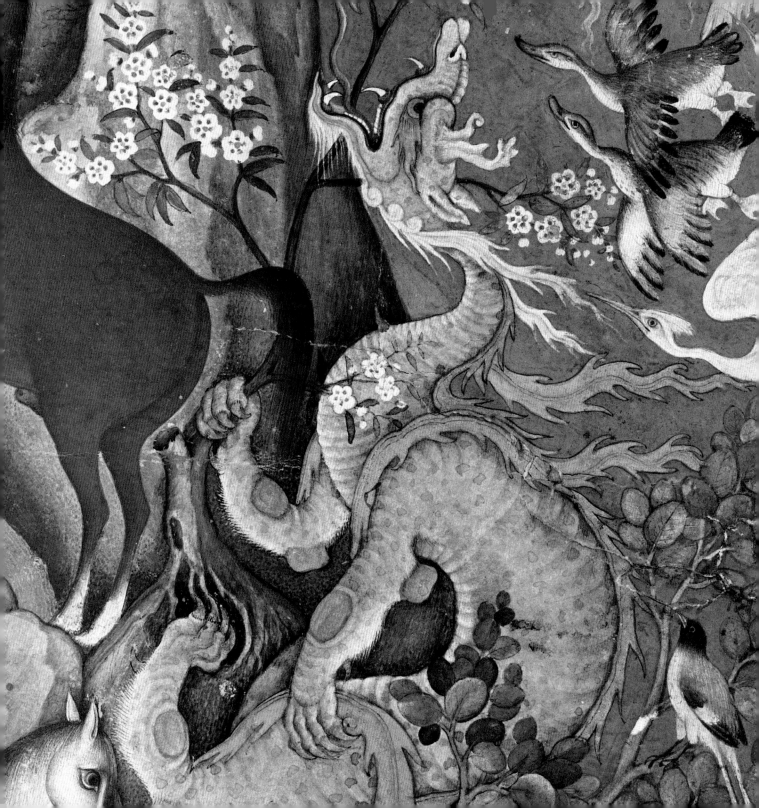

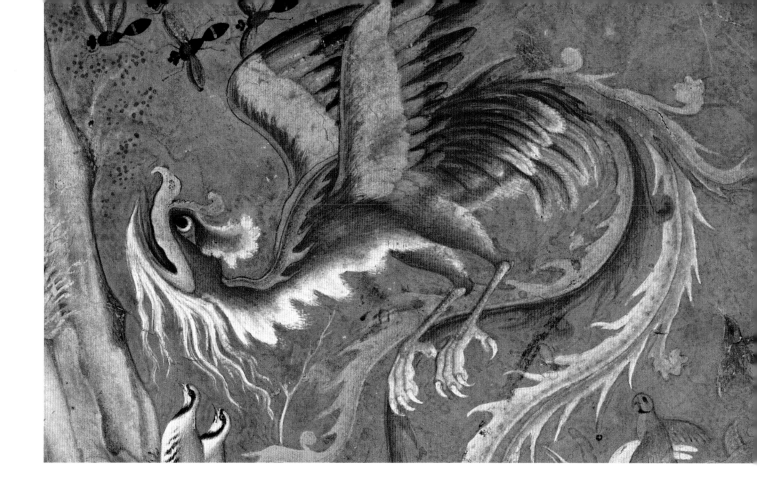

Two details from 'The raven addresses the assembled animals', from a dispersed book of fables, Mughal India, attributed to Miskin, *c.* 1590. Opaque watercolour and gold on paper.

Above: The phoenix-like bird, the simurgh, possessed magical powers, and its feathers could heal the most grievous wounds. Here it hovers with birds and insects above the dragon, with which (in other contexts) it often fights.

Left: The dragon slithers up a steep mountainside to listen to the raven standing near the peak. This Chinese-style dragon was classed with snakes and other reptiles, while the makara, an indigenous Indian dragon, was grouped with amphibians.

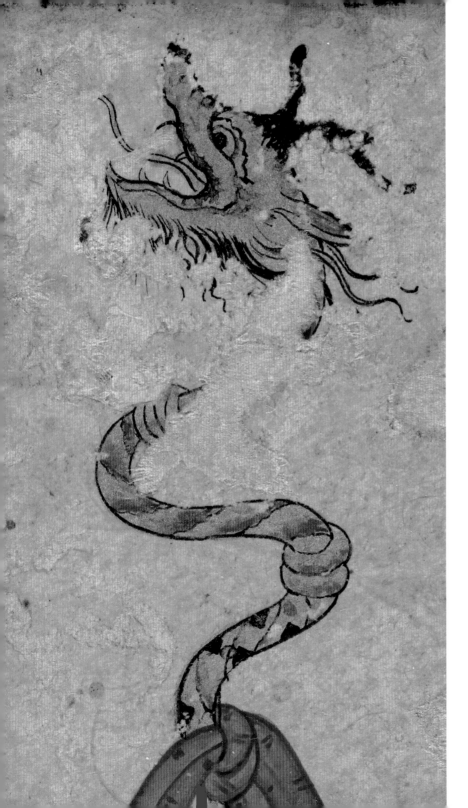

Left: Detail from a portrait of a dervish, Mughal India, *c.* 1570–80. Opaque watercolour and gold on paper.

The dragon-headed terminal of the dervish's staff was intended to ward off evil. Its ferocious wagging tongue and glaring eye emphasize the prophylactic powers of the beast. In addition to its astrological symbolism, the dragon appears as a protective figure on city gates and thrones. Although the makara, a native Indian form of dragon based on the crocodile, had long been a feature of the supernatural landscape, Mughal artists adopted the Chinese style of dragon, presumably by way of Persian painting. This type had a shorter snout, a beard or flame beneath its chin, horns, a sinuous body and flaming wings.

Right: Detail of Sagittarius from the 'Vaso Vescovali'.

Sagittarius is depicted in the form of a centaur shooting at its own dragon-headed tail.
The centaur's human forepart represents Jupiter, the planet-lord of Sagittarius, while the dragon symbolizes one of the two imaginary planets thought to be responsible for lunar eclipses.

4

The natural world

The terrain of the Islamic world, reaching from Spain to India, embraces most of the earth's geographical and climatic features. Deserts and mountains, jungles and plains, seas and rivers – with all their native animals and plants – can be found in this broad and varied swathe of territory. While responses to the natural world have been conditioned by the local environment, narrative requirements and artistic conventions have also influenced the appearance of flora and fauna, whether in manuscript illustrations or the decoration of architecture and objects. Whereas early Islamic depictions of flowers and plants are often highly stylized and botanically unrecognizable, in later Islamic art from Turkey, Iran and India particular species of flowers and plants can be identified. While many animals indigenous to North Africa, the Middle East, Central Asia and India figure in Islamic bestiaries, those associated with the hunt as well as domesticated breeds, some insects and a variety of birds appear on objects and textiles and in the arts of the book.

Because of the Arabian origin of early Islam and the homogeneity of the desert lands into which it first expanded, namely the modern states of Jordan, Iraq, Syria, Egypt and Iran, the types of animals specifically mentioned in the Qur'an would have been familiar to early converts even if they were not natives of the Arabian peninsula. Thus camels, cattle, sheep, oxen and goats are all cited as domesticated animals in the Qur'an. In addition to denouncing as inhumane certain pre-Islamic practices concerning animals, the Qur'an follows the Judaeo-Christian tradition in claiming animals as God's creatures: 'There is not an animal on the earth nor a being that flies on its wings, but [forms part of] communities like you. Nothing have we omitted from the Book, and they [all] shall be gathered to their Lord in the end.' (6:38) Appearing in the Qur'an as 'steeds of war', horses were highly valued across the Islamic world and were bred for strength and speed.

While the early Muslims adhered to the Judaeo-Christian taboo against human sacrifice, they did perform the ritual sacrifice of animals, particularly camels and sheep. This was seen as an act of piety, but it also served the practical purpose of supplying meat for food, both to the person performing the sacrifice and to the needy. Wild animals, of course, were hunted and were also legal for Muslims to eat, except in certain restricted situations.

'Rustam sleeping while Rakhsh fights the lion', from a dispersed unfinished *Shahnameh*, Iran, Tabriz, attributed to Sultan Muhammad, c. 1515.

The three protagonists of this illustration – the epic hero Rustam, his horse Rakhsh and the lion – are dominated by the towering trees, jutting rocks inhabited by hidden grotesques, and windswept sky of the landscape that surrounds them.

couches lined with brocade, the fruits of the garden nigh to gather . . . therein maidens restraining their glances, untouched before them by any man or djinn . . . lovely as rubies . . . green, green pastures . . . therein two fountains of gushing water . . . therein fruits, and palm-trees, and pomegranates . . . therein maidens good and comely . . . houris, cloistered in cool pavilions . . . untouched before them by any man or djinn . . . reclining upon green cushions and lovely druggets.' The mention (twice) of two fountains may imply four gardens: the classic format of the Persian garden, the *chahar bagh*, is a rectangle divided into four sections by the watercourses that intersect it and meet in the middle.

One of the most important early Islamic monuments outside Arabia, the Great Mosque in Damascus, is decorated with an extensive mosaic programme featuring buildings in a landscape of towering deciduous trees growing near a river. In the 9th century the stylization of vegetal forms led to the use of palmette leaves and vines instead of acanthus leaves and bunches of grapes. Various flowers were included in Qur'anic manuscript illumination and in bands of ornament on metalwork and ceramics. However, flowers are often simplified into forms such as the rosette or simple four- or five-petalled blossoms. While books on the medicinal properties of plants included botanically correct illustrations, a return to naturalism in Islamic ornament did not occur until the 16th century in Turkey, Iran and India.

The Islamic view of the world of plants is influenced both by local conditions and by Qur'anic descriptions of paradise. Gardens are mentioned over 130 times in the Qur'an, usually in the context of paradise and often in contrast to the fiery wasteland of hell. One section of the Qur'an (55:45–76), punctuated by the question 'O which of your Lord's bounties will you and you deny?', describes the gardens that await the god-fearing. They will be 'abounding in branches . . . therein two fountains of running water . . . therein every fruit two kinds . . . reclining on

Animals

Animals have traditionally played significant roles in the art and literature of the Arabs, Turks, Persians and Mughal Indians. Collections of fables such as *Kalila wa Dimna* feature a pair of jackals as the protagonists, along with many other animals through the narrative cycle. In the *Shahnameh*, the Persian national epic, horses sometimes rival humans in heroism, while wild beasts such as lions are often bested by men. Talking birds appear in poems such as *The Conference of the Birds* of Fariduddin ʿAttar or the *Khamseh* of Nizami. In all these texts, animals and birds have their own personalities, their actions and concerns mirroring those of humans.

Scientific and pseudo-scientific literature also focuses on animals. A late 13th-century Mongol manuscript of *The Usefulness of Animals* (*Manafiʿ al-Hayawan*) of Ibn Bakhtishu contains illustrations of a range of animals and provides practical information about their behaviour. Likewise, the encyclopaedic *Wonders of Creation* of Qazvini includes lore about actual as well as fantastic animals. One particularly helpful form of literature, called furusiyya, is devoted to horses and horsemanship and deals not only with training horses but also their use in military exercises. While some illustrations of animals are closely analogous to the text, others rely on a chain of artistic prototypes stretching back to ancient Near Eastern stone reliefs.

Beyond the literary context, representations of animals are found on all media. Their precise meaning is often elusive, however. Scenes of one animal attacking another – lions overcoming deer or antelopes, or hawks overpowering geese – symbolize the power of the strong over the weak. Birds of indeterminate species adorn metal incense burners, cameo glass bottles, 10th-century Egyptian textiles and 12th-century Iranian ceramic bowls, to name but a few examples. Like the many tiles and ceramic and metal bowls with images of rabbits or hares, the use of birds may have generally positive associations. As creatures of the air, birds may have been considered appropriate to incense burners, from which the aroma is carried on the air, but this would not explain the symbolism of the early Islamic metal ewers in the shape of a bird, or medieval ceramic ewers with spouts like birds' heads.

In 16th- and 17th-century India, the interest of the Mughal emperors in the flora and fauna of the subcontinent and their taste for naturalism led to new developments in animal painting and a continuing presence of animals on three-dimensional objects of all kinds. In the late 16th century, the emperor Akbar commissioned illustrated editions of the memoirs of his grandfather Babur, the Central Asian Mughal prince who first conquered northern India. The

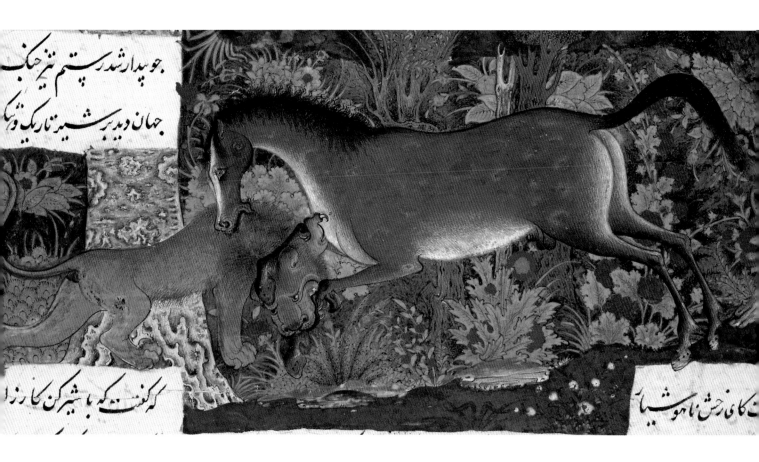

 جو پدار شد رستم تنیر جنک

جهان دید بر شیه تار یک و تنگ

که کفت ن که با شیر کن کار زا

کای نرخش ماہو شیا

Detail from 'Rustam sleeping while Rakhsh fights the lion', from a *Shahnameh*, Iran, Tabriz, attributed to Sultan Muhammad, *c.* 1515.
When Rustam unwittingly falls asleep near a lion's lair, his horse Rakhsh attacks and kills the lion.

environment of India was so different from Central Asia that Babur recorded his wonder and fascination with all the new creatures he encountered. The artists who illustrated his memoirs half a century later captured this curiosity and amazement in highly sensitive paintings of elephants, tigers and other Indian animals. Manuscripts and pages of calligraphy in Mughal albums of the reign of Shah Jahan (1627–58) were adorned with tiny birds, realistically portrayed, in pairs, which ultimately harks back to the medieval practice of illustrating animals in male-female pairs.

In 16th-century Iran and India, the puzzling genre of depicting composite animals gained popularity. In paintings, carpets and ivory powder horns one animal is shown consuming or disgorging another, which may in turn be swallowing another. These composites may have a mystical (Sufi) meaning, suggesting the impermanence of the material world and the constancy of change.

Left: Detail of a page of poetry in nasta^cliq script, Mughal India, copied in Burhanpur, dated AH 1140/AD 1630–31.

Seen with the naked eye, the tahrir (cloud forms enclosing the calligraphy) appear to contain marbling. However, the close-up view in raking light reveals animals consuming or disgorging one another, painted in gold. The composite animals are drawn in both orientations in relation to the script (here shown upside down). In the centre a fish transforms into a fox, and below a lion's head faces right while its back metamorphoses into a hyena.

Left: Detail from 'Rustam sleeping while Rakhsh fights the lion'.

This tiny detail, of a snake gliding up a tree to steal the chicks from a bird's nest, may be an echo of the main episode of the painting: the victory of one animal over another.

Above: Detail from a page of poetry in nasta^cliq script.

The Mughal emperor Jahangir (r. 1605–27) possessed a serious interest in birds and animals and employed several artists who specialized in rendering the varied fauna of India, such as this black-capped kingfisher.

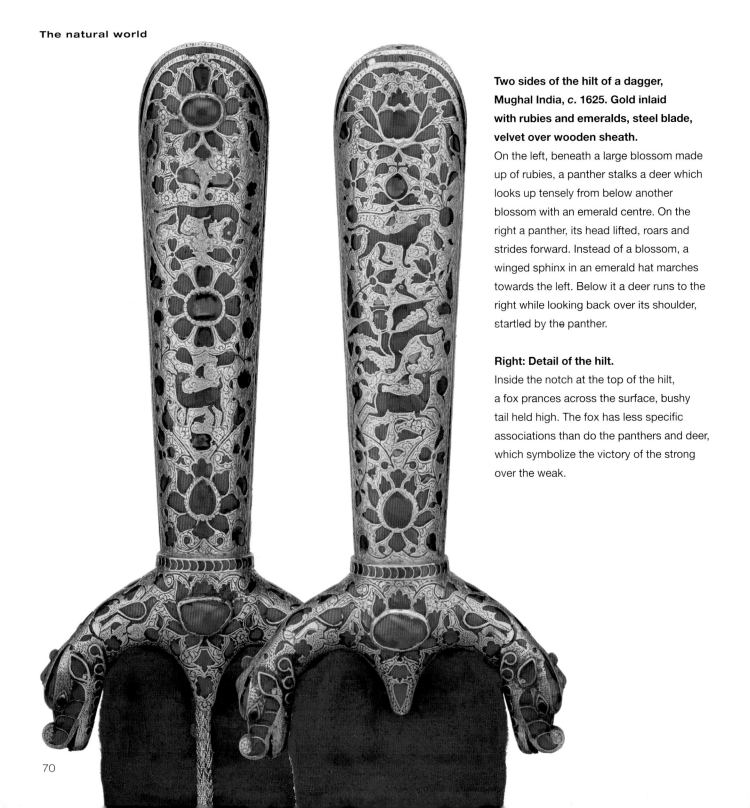

Two sides of the hilt of a dagger, Mughal India, *c.* 1625. Gold inlaid with rubies and emeralds, steel blade, velvet over wooden sheath.

On the left, beneath a large blossom made up of rubies, a panther stalks a deer which looks up tensely from below another blossom with an emerald centre. On the right a panther, its head lifted, roars and strides forward. Instead of a blossom, a winged sphinx in an emerald hat marches towards the left. Below it a deer runs to the right while looking back over its shoulder, startled by the panther.

Right: Detail of the hilt.

Inside the notch at the top of the hilt, a fox prances across the surface, bushy tail held high. The fox has less specific associations than do the panthers and deer, which symbolize the victory of the strong over the weak.

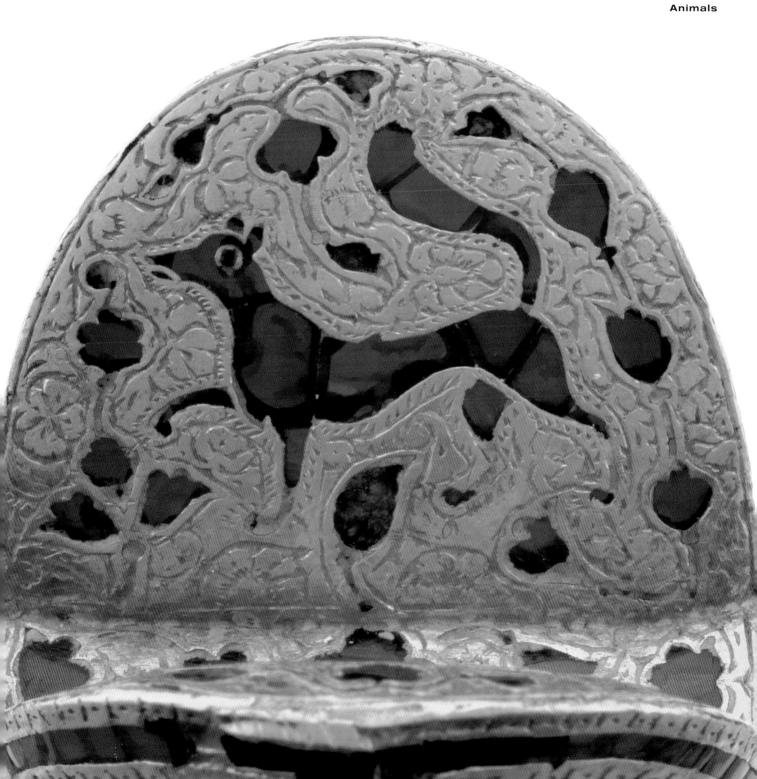

'Lion attacking a deer', Ottoman Turkey, second half of the 16th century. Cut-out paper and opaque watercolour on paper.
These three details reveal the virtuosity achieved by Ottoman Turkish masters of decoupage. Even the tiny white markings on the bird (below) have been pasted on its breast.

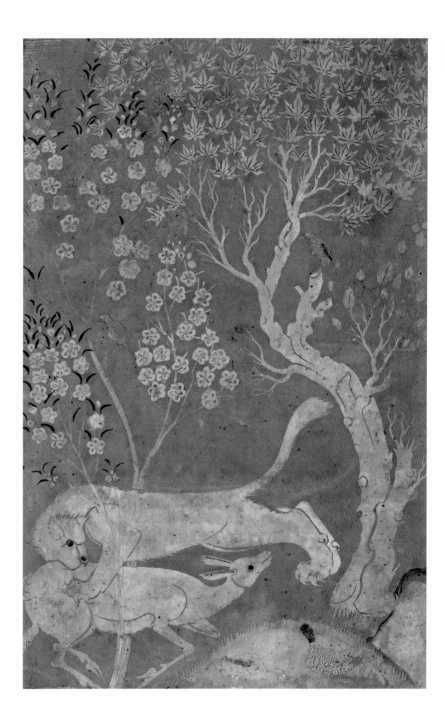

The lion attacking a deer is a common image of victory and the dominance of the strong over the weak – in contrast to the peaceful setting of flowering shrubs, ducks in their pool, and birds in the trees. The close-up opposite reveals the subtle marbled pattern of the duck's body, its yellow legs and golden upturned tail.

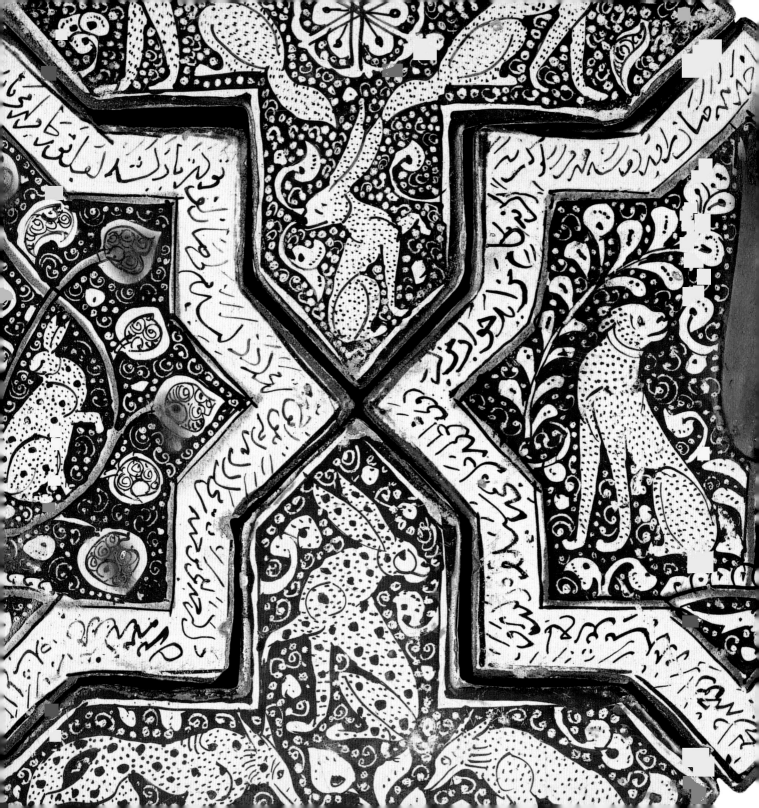

Details of star-and-cross tiles.

On either side of a cypress tree two addorsed cheetahs, with collars and different spot patterns, turn their heads to look at one another while a fish swims upside down in a pool in front of the tree.

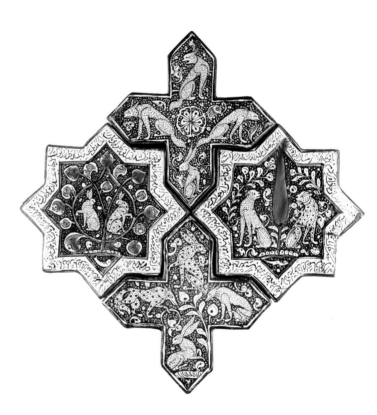

Four star-and-cross tiles, Iran, Kashan, *c*. 1260–70. Ceramic stonepaste body and lustre overglaze, opaque white glaze and turquoise inglaze.

The cheetahs, hares and wolves in these tiles are just a few of the wide range of real and imaginary animals used to decorate tiles for palaces and other domestic settings.

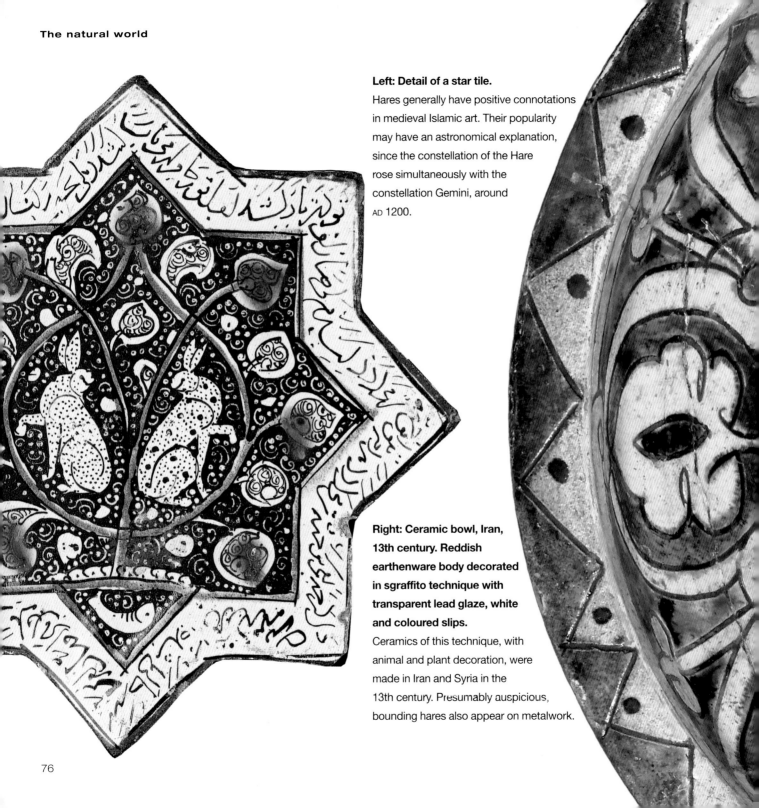

Left: Detail of a star tile.
Hares generally have positive connotations in medieval Islamic art. Their popularity may have an astronomical explanation, since the constellation of the Hare rose simultaneously with the constellation Gemini, around AD 1200.

Right: Ceramic bowl, Iran, 13th century. Reddish earthenware body decorated in sgraffito technique with transparent lead glaze, white and coloured slips.
Ceramics of this technique, with animal and plant decoration, were made in Iran and Syria in the 13th century. Presumably auspicious, bounding hares also appear on metalwork.

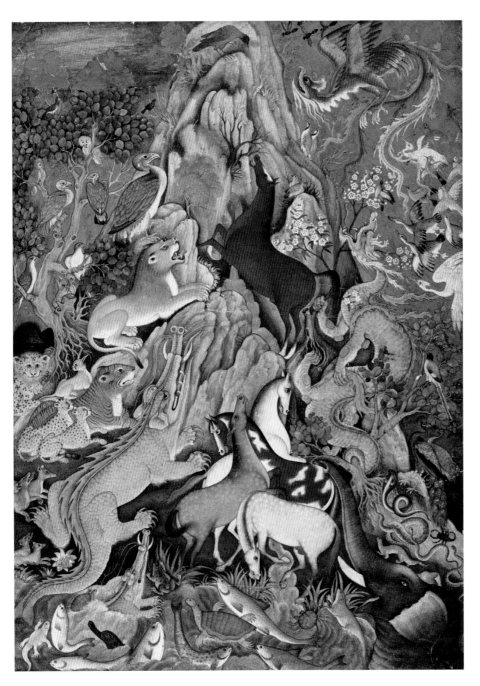

'The raven addresses the assembled animals', from a dispersed book of fables, Mughal India, attributed to Miskin, *c.* 1590. Opaque watercolour and gold on paper. Amidst a cacophony of growls, whinnies and buzzing, the raven, perched on a rock near the top of the mountain, addresses the animal kingdom.

Right: The big cats – tiger, cheetah, lynx, leopard and lion – have been sensitively rendered by Miskin, a specialist animal painter at the court of Akbar (r. 1556–1605). A black bear lurks behind the comically smiling leopard, who does not appear to be quite as riveted to the raven's words as are the other animals.

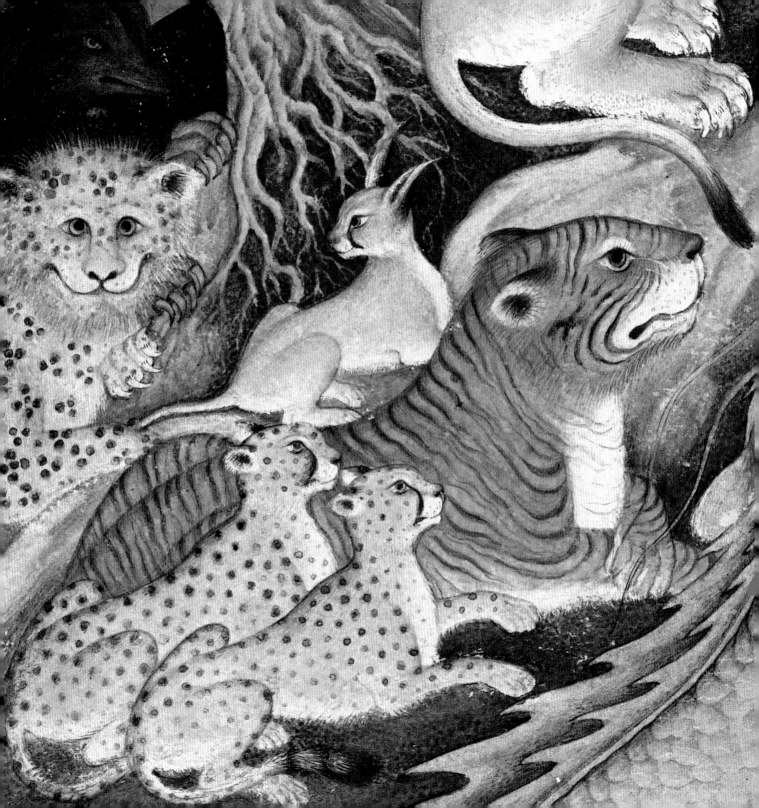

Plants

With the exception of illustrations in scientific manuscripts such as a 13th-century *De Materia Medica*, plants play a supporting role in Islamic art until the 16th century. The inclusion of a single stalk with blossoms in a painting, or the tendrils of an arabesque around representations of a rider or musician on an inlaid metal ewer, was sufficient to imply that the scene is set in a landscape. Whether rendered in a stylized form or naturalistically, plants are ubiquitous in Islamic decorative arts, textiles, the arts of the book, and architecture. In some cases, such as tile panels on mosques or mausolea, the use of vegetation may be an indirect reference to paradise. However, generally the inclusion of trees, shrubs, flowers and vines provides either a foil to the main focus of the ornament or an all-over pattern with the same function as drapery.

Some floral or vegetal motifs, such as the lotus, entered the vocabulary of Islamic art from Iran to Egypt in the 13th century as a result of the Mongol invasions. Others had a specific iconography: for instance, in Persian poetry and art, a cypress entwined by a rose was a metaphor for a handsome youth and his beautiful lover. In the 16th-century Ottoman Turkish ceramic production centre of Iznik, a new type of pottery was developed in which the main decorative elements were serrated 'saz' leaves, tulips, hyacinths, roses and carnations. Tulips had been cultivated in Turkey for 500 years before becoming a staple of Ottoman design. By the end of the 16th century they had been introduced to Europe, leading in the 1630s to 'Tulipmania', a wild bubble of speculation in bulbs by the Dutch. This interest, in turn, resulted in the production of European flower prints which were then exported in the late 16th and 17th centuries back to Iran and India. Mughal Indian artists not only painted single flowers for inclusion in albums but also decorated margins and calligraphies with tulips and other species.

Detail from a portrait of Shah ᶜAbbas I (r. 1587–1629), Mughal India, attributed to Bishn Das, *c.* 1619. Opaque watercolour and gold on paper. As a design element, flowers are omnipresent in Islamic art. The robe worn by Shah ᶜAbbas (below) is decorated with these rows of tiny gold flowers and narrow stripes.

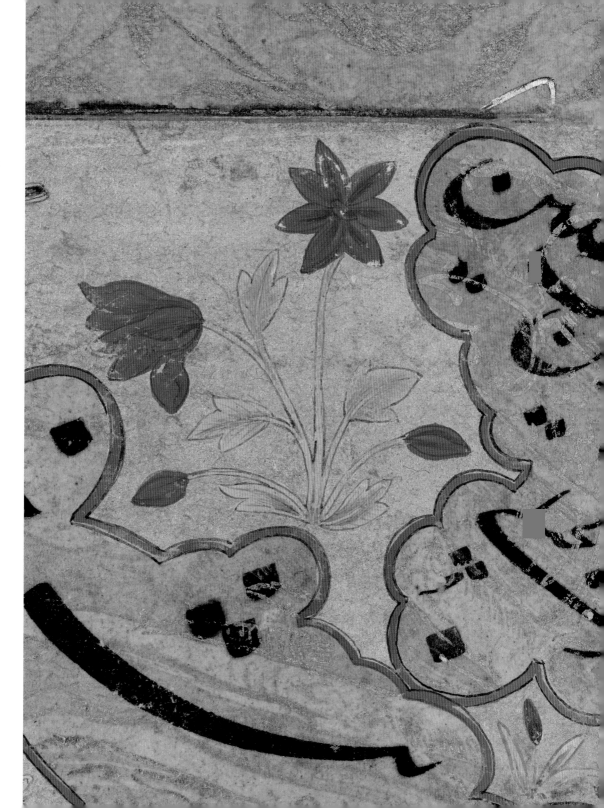

Detail of a page of poetry in nastaᶜliq script, Mughal India, copied in Burhanpur, dated AH 1140/AD 1630–31. Following in the tradition of the Mughal emperors Jahangir and Shah Jahan, Dara Shikoh – the probable calligrapher of this page – demonstrated an interest in flowers as reflected in the tulips and other species depicted between and around lines of calligraphy.

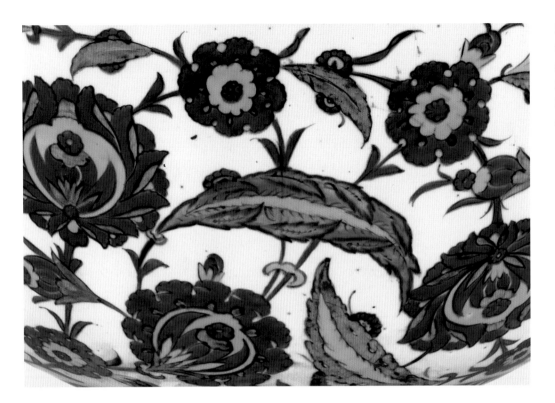

Right: Tulips, carnations and prunus blossoms adorn the central cobalt blue roundel inside the bowl, out of which grow clumps of purple tulips.

Large footed bowl and details of its exterior and interior. Ottoman Turkey, Iznik, c. 1545–50. Ceramic stonepaste body and turquoise, blue, black and green underglaze and transparent colourless glaze.

In the mid 16th century Iznik potters produced a series of imperial-quality ceramic objects and tiles, decorated with floral motifs in cobalt blue, turquoise, sage green and manganese purple. They combined stylized flowers, such as the lotus sections shown in the detail above, with lancet leaves, rosettes and poppy buds in wonderfully rhythmic arabesques and simple interlaces, as on the foot of the bowl. The bands of white tulip buds in cartouches around the base and the foot also unite nature and artifice in a perfect balance.

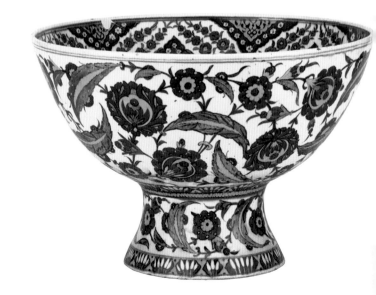

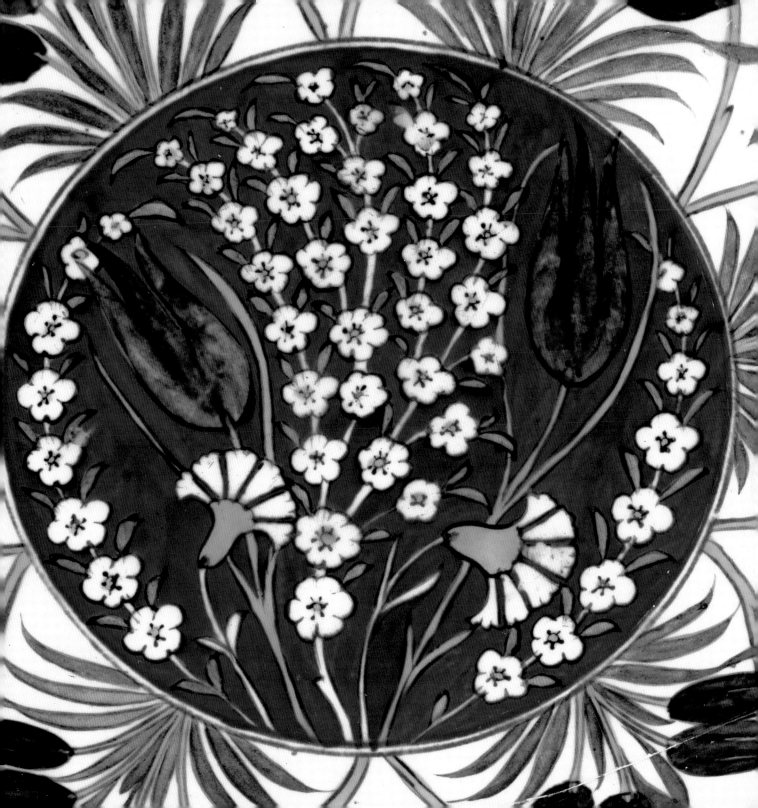

Left: Detail from a page of poetry in nasta⁽liq script, Mughal India, copied in Burhanpur, dated AH 1140/ AD 1630–31.
Purple, red and pink tulips and birds such as this red-eyed pheasant adorn the areas between cartouches containing writing on this page. Tulips grew wild in Kashmir and were very popular with the Mughals.

Right: Detail from 'Rustam sleeping while Rakhsh fights the lion', from a *Shahnameh*, Iran, Tabriz, attributed to Sultan Muhammad, *c.* 1515.
Seemingly unconcerned about the relative proportions of flowers, shrubs and trees, the artist has represented the meadow with the wind whipping through its lush vegetation.

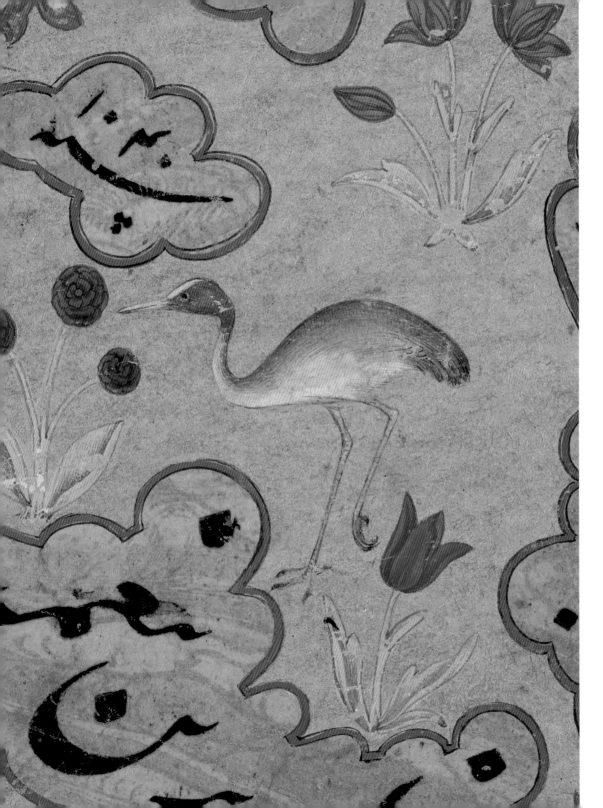

Detail from a page of poetry in nasta^cliq script.
A red-headed Sarus crane picks its way through the gold ground out of which grow red tulips and a purple ranunculus. Ranunculus asiaticus is native to Iran and Turkey and may have been taken to India during Mughal times by one of the many Iranians who emigrated there.

Detail from 'Lion attacking a deer', Ottoman Turkey. Cut-out paper and opaque watercolour on paper.
A close-up view of these leaves suggests an almost abstract pattern, whereas in the composition as a whole they provide a leafy counterpoint to flowering shrubs, birds and animals in combat.

5
Feasting

With the advent of Islam in the 7th century, eating pork and drinking wine were forbidden. Additionally, the Qur'an (5:4) prohibits consumption of dead meat, blood, or animals killed by strangling, a violent blow, gored to death or partly eaten by a wild animal. Although the Qur'an rejects the earlier food taboos of the Jews, it states that food acceptable to the People of the Book (Christians and Jews) is also lawful for Muslims. Despite its illegality, wine continued to be produced by non-Muslims and imbibed by some Muslims. The serving and drinking of wine appears in wall paintings on early Islamic secular buildings and also on portable objects from Egypt, Syria, Iraq and Iran. While the style derives from local pre-Islamic traditions, the subject is invariably connected with feasting and merry-making.

The Muslim conquests also opened trade routes from Spain to Central Asia. Foods such as melons from Central Asia and dates from Arabia were sent to Baghdad, and spices from East Asia and Africa were traded throughout the Muslim world. Additionally, other fruits such as apricots, oranges, lemons and pomegranates, which were grown in Iran, became available to

Muslims along the southern shores of the Mediterranean. The resulting cuisine combined Arab urban foods – wheat and vegetables – and nomad staples (dates, camels', sheep's and goats' meat and milk) with more exotic Persian fare including bananas, artichokes, rice, sugar cane, aubergines and saffron. Under the ʿAbbasid caliphate, from the 8th to the 13th centuries, these and other ingredients were used to create new dishes such as grilled kebabs, meat pies, stews combining meat and fruit, and sorbets.

Concern with the presentation of food extended to the containers in which it was served. The majority of Islamic bowls, ewers, cups and platters reflect the interest across the Muslim world in appealing to the eye as well as the palate and the nose when proffering food and drink. Although Islam is averse to the use of silver and gold, royal households did serve food on and in vessels made of these precious metals. However, few examples survive; instead, brass objects inlaid with silver, gold and copper, and lustreware ceramics, mimic the glittering effects of gold without breaking any religious law.

In traditional Islamic societies, extended families lived together, either under one roof or

**The 'Blacas' ewer,
northern Iraq, Mosul,
signed Shujaᶜ bin
Manᶜa, dated
AH 629/AD 1232.
Brass inlaid with silver
and copper.**
This ewer is a crucial
document for the
study of inlaid
metalwork from Mosul,
although its spout and
cover are lost.
It is decorated with
drinkers, but was likely
to have been used to
pour water, since brass
has an adverse effect
on wine.

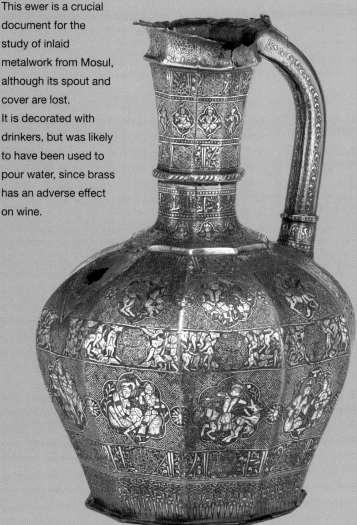

in tribal groupings. As a result, cooking for a crowd was the norm. One of the few extant cookery books, the *Niᶜmatnama*, from the early 16th-century Indian sultanate of Mandu, contains recipes calling for whole sheep and huge quantities of rice, vegetables and other ingredients to serve the court of the sultan. The most lavish feasts were reserved for special occasions, such as the birth of a son or the marriage of a prince. The emperor's party planners outdid themselves for the wedding celebration of six of the grandsons of Timur (Tamerlane). In 1404, in a meadow near Samarkand, vast tents were raised and adorned with jewels and gold, and entertainers of every kind gathered at the site. After the marriage was performed, the princes toasted each other while drinking wine, fermented mare's milk, honey, distilled liquor and sorbet. Then 'trays laden with more food and multitudes of more various edibles were set than can be described', followed by platters of fruit. After the grandees had been served, food and drink were given to 'soldiers and townspeople, old and young, Damascene, Greek, Persian and Turk'.

With the Ottoman conquest of Constantinople in 1453 and the expansion of the empire around the shores of the Mediterranean from Serbia to North Africa, a new cuisine spread through the western Islamic world. This featured stuffed vegetables, yogurt, pilaffs and sweet pastries with nuts drenched in honey or syrup. Meanwhile, in India, the spicy ingredients used for curries were combined with the rice and mutton dishes of Iran and Central Asia. At the Mughal court of Akbar, even the elephants were fed chillies!

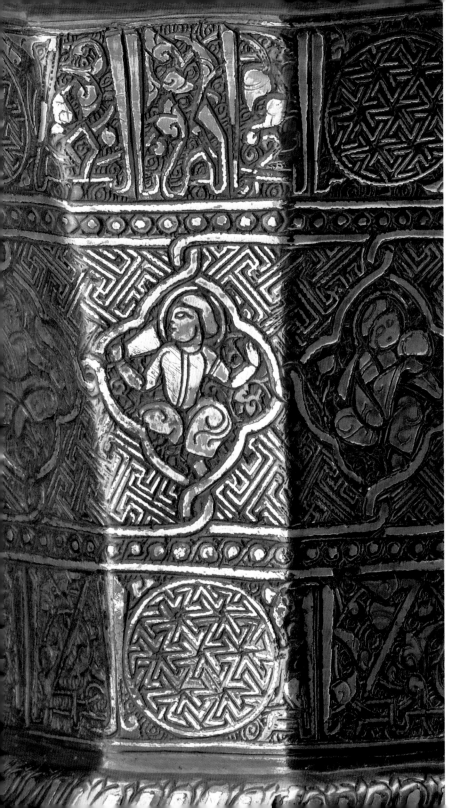

Left: Detail from the 'Blacas' ewer.
This seated drinker, placed within a four-lobed cartouche, appears within a band of musicians and dancers around the neck of the ewer. The shape of his beaker resembles enamelled glass examples from Mamluk Syria or Egypt such as this pilgrim bottle (right).

Right: Detail from a pilgrim bottle, Syria, 1340–60. Gilded and enamelled glass.
This seated figure is undoubtedly drinking wine from the goblet he clasps with his right hand, while another beaker seems to float over his left shoulder and a long-necked bottle sits to his left, ready to fill an empty glass. A platter of fruit accompanies the wine.

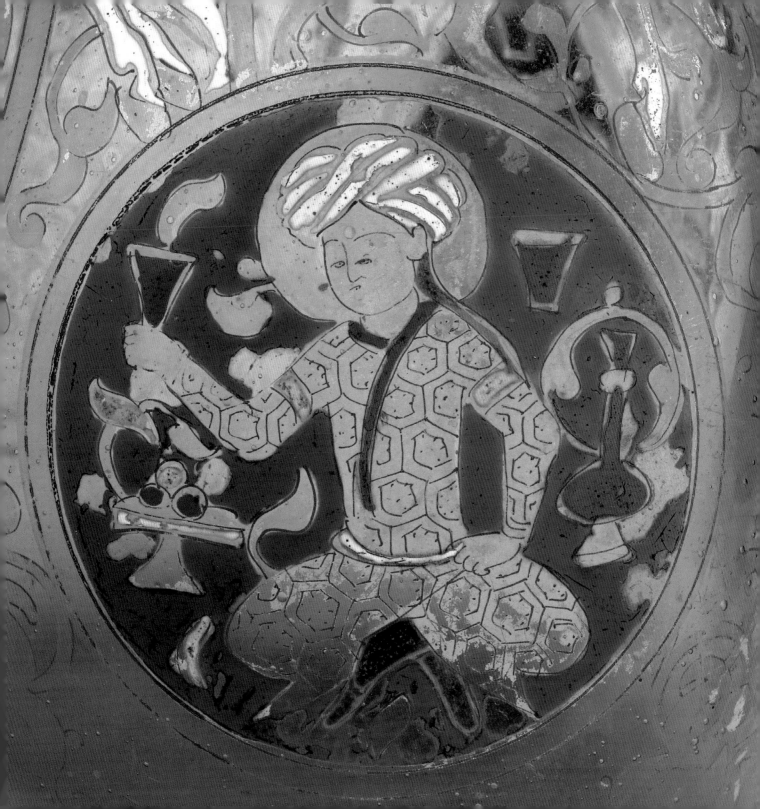

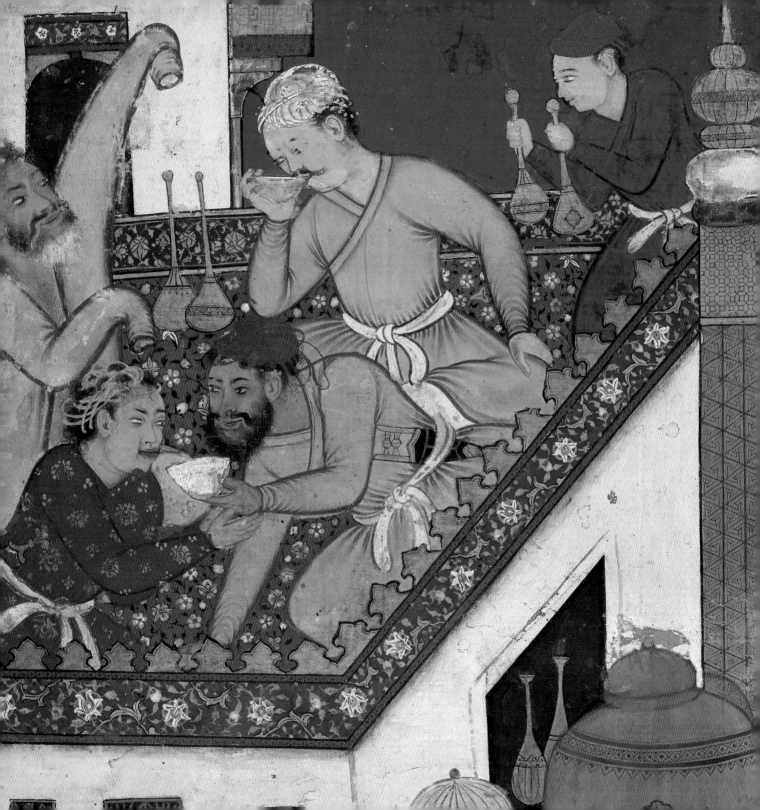

'Farid observes a drunken scene', *Dastan-i Amir Hamza***, Mughal India,** *c.* **1562–79. Opaque watercolour and gold on paper.**

Although European visitors to Safavid Iran and Mughal India describe feasts and the foods consumed at them, paintings and illustrations are far more likely to focus on drinking than on eating. This illustration of the activities taking place within the walls of the palace shows alcohol production and consumption from fermentation and decanting to drinking and drunkenness.

Left: In this detail, a young boy rushes with two bottles to the balcony where a bearded man offers a cup of wine to a youth, while a moustachioed man drinks from his bowl.

Left: Detail from a carved ivory panel, Mamluk Egypt, 14th century.
This figure carries a bottle in his left hand and what may be a cloth in his right. Although he wears a turban, his long hair reaches his shoulders. The bands on his arms contain pseudo-writing but represent tiraz bands, inscribed with the name of the caliph and his titles. From these features one can surmise that this is a servant and most likely a Muslim, although Christian figures also appear on this ivory plaque and its partner.

Detail from 'Farid observes a drunken scene'.
A servant decants red wine from one painted earthenware pot to another. There are a few small covered dishes, but they are insignificant compared to the number of wine containers.

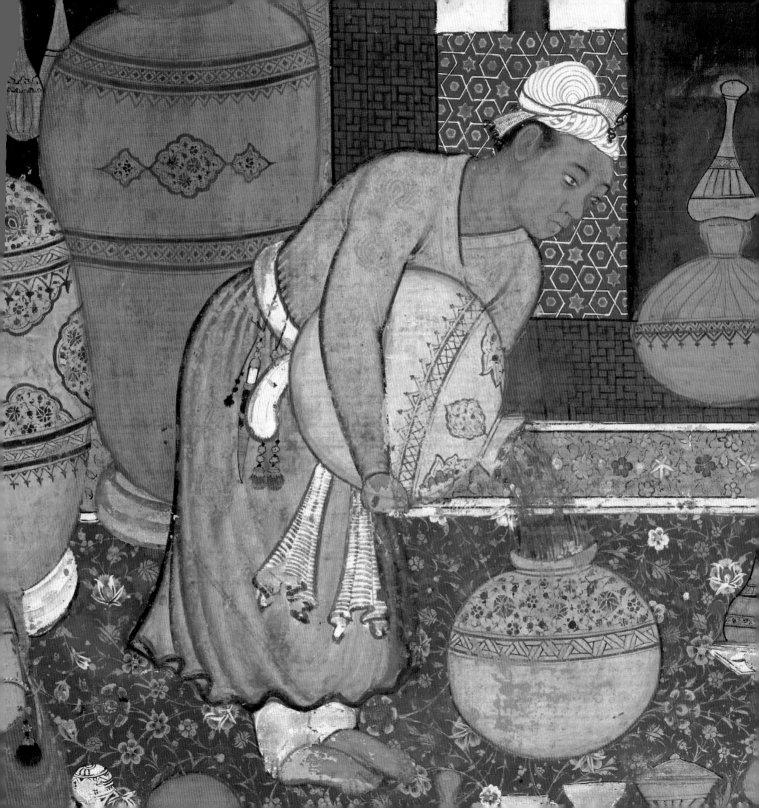

The 'Vaso Vescovali',
lidded bowl, Iran or
Afghanistan, Khurasan
province, *c.* 1200.
High-tin bronze inlaid
with silver.
In addition to the
astrological imagery on
the lid and sides of this
bowl (see chapter 3),
the narrow band that
runs around the rim
consists of pairs of
seated drinkers,
musicians and
merry-makers.

Right: Detail from
'Farid observes a
drunken scene'.
This figure, with his
dishevelled knot of a
turban, open coat and
untied trousers, is
clearly paying the price
of his overindulgence.
With one eye open and
the other nearly shut, he
is about to relieve
himself – the result of
too much 'feasting'.

6

The hunt

The imagery of the hunt has an ancient lineage in pre-Islamic Arabia, Western Asia and Egypt. Arabian petroglyphs of archers and their prey, stone reliefs of Assyrian kings hunting from chariots and Egyptian wall paintings of men hunting birds all attest to the actual and symbolic importance of hunting. Two types of image served as immediate prototypes for early Islamic depictions of the hunt. In Iran, reliefs on the stone walls of Taq-i Bustan, a Sasanian site, contain a panoramic boar hunt with the king, presumably Khusrau II (591–628), shooting arrows from a boat, and a deer hunt in which he and his much smaller associates give chase across a plain, apparently within an enclosure. In contrast, Sasanian and related early Islamic silver plates portray the king, either mounted or standing, in single combat with his prey. By the 9th century, images of falconers on horseback decorated the walls of a building at Nishapur in Iran, and a lion hunt was painted on the wall of an audience hall at Samarra. Yet, in these early centuries of Islam, horsemen depicted on ceramics tended to be warriors rather than hunters, and panoramic hunts are generally absent.

With the advent of the rival Shiᶜa caliphate of the Fatimids in North Africa and Egypt from 909 to 1171, the image of the mounted falconer reasserted itself, appearing on lustre-glazed ceramics. Under the Ayyubids, successors to the Fatimids, and the Atabegs of Mosul, the vignette of the hunter on horseback became firmly established in the standard programme of royal imagery found especially on inlaid metalwork, enamelled glass and carved wooden panels. Though sometimes schematic, these renderings of hunters exhibit a range of methods and types of game. Although bows and arrows were most commonly used, hunters also employed pikes and swords, and some images even show boys blowing pebbles through small pipes to kill birds.

Royalty and those who could afford the upkeep hunted with hawks. Depending on their size and species, these were either high-flying hunters of other birds such as cranes or low-flying predators in pursuit of mammals. Salukis (seluqi: Persian and Arabian greyhounds) were the only dogs considered acceptable in Islam, and they chased deer and similar antlered species. However, the most expensive and elegant animal used in the hunt was the cheetah. Once tamed, a

Detail of pilgrim bottle, Syria, 1340–60. Gilded and enamelled glass.
On the shoulder of the bottle a mounted hunter spears a wolf while a hare flees. The pose recalls images of St George and the Dragon.

been painted on the walls of palaces and hunting lodges of the 13th to 15th centuries, no evidence remains. Such images make their appearance in book painting in the 15th century, first in the *Shahnameh* of 1430 produced for Prince Baysunghur, one of Timur's grandsons, followed in the 1460s by a double-page scene portraying the Qaraqoyunlu Turkman ruler, Uzun Hasan, riding full tilt down a mountain valley with his courtiers in pursuit of various types of game. In such frontispieces, which bore no relation to the narrative of the book in which they were placed, the patron was presumably being depicted as he wished to be seen. The virility and athleticism of Uzun Hasan the hunter would mirror his prowess on the battlefield – in theory, if not in practice.

Whereas 16th-century Persian representations of panoramic hunts combined stock figures and borrowed vignettes with realistic passages, Mughal painters strove to reproduce all the details of the hunts described in the memoirs or histories of their emperors. Paintings from the *Akbarnameh* depict battues, in which fences were erected around vast swathes of territory in order to enclose the game which were then slaughtered over several days. Yet, even as late as the 17th century, an episode in which Jahangir killed a lion that was attacking one of his attendants was transformed into an iconic image of the emperor overcoming the king of beasts – a symbol thousands of years old.

cheetah could ride on the rump of a hunter's horse and be sent off to chase game. It was trained not to eat the game, since if it did the meat would be illegal for men to consume.

Persian manuscript paintings contain many hunting scenes, either to illustrate famous heroic hunters such as Bahram Gur and Rustam or because their frontispieces portray the princes and kings who commissioned the manuscripts enjoying a hunt of the panoramic variety. While grand multi-figure hunting scenes may have

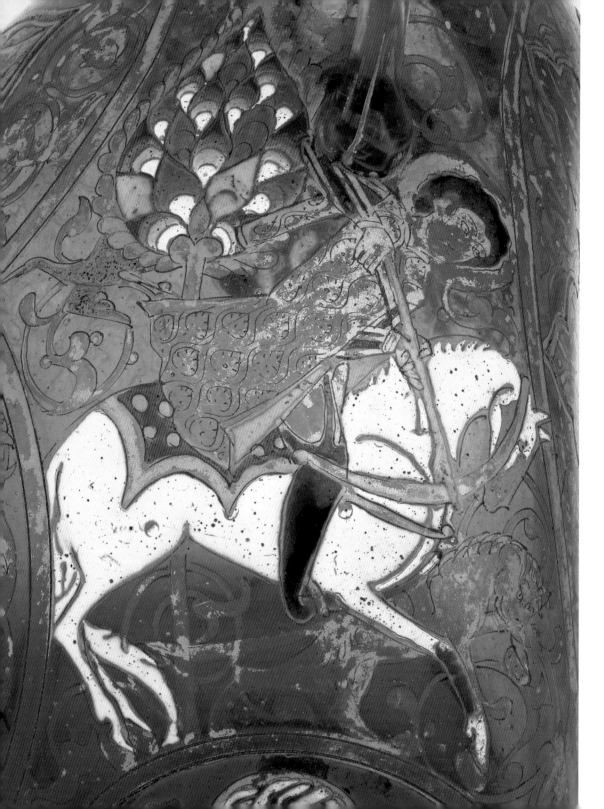

Detail of pilgrim bottle.
Bareheaded and haloed, a hunter in a brocade cape rises in his saddle to shoot a lion with his crossbow. Behind him is a tree with multicoloured foliage, and a large blue bird flies away to the left. The other hunter depicted on this bottle wears a Frankish hat.

Detail from the 'Blacas' ewer.
This mounted hunter has just let an arrow fly into a wolf. Holding two arrows in his right hand, the hunter has twisted his torso in order to shoot the wolf, which has reared up at the horse's back. This pose recalls the ancient 'Parthian shot', in which a hunter or soldier discharges his arrow at the quarry behind him while his horse gallops forward. The vignette appears in an eight-lobed medallion on the side of the ewer, along with nine other scenes of hunting, fighting, music-making and courtly life.

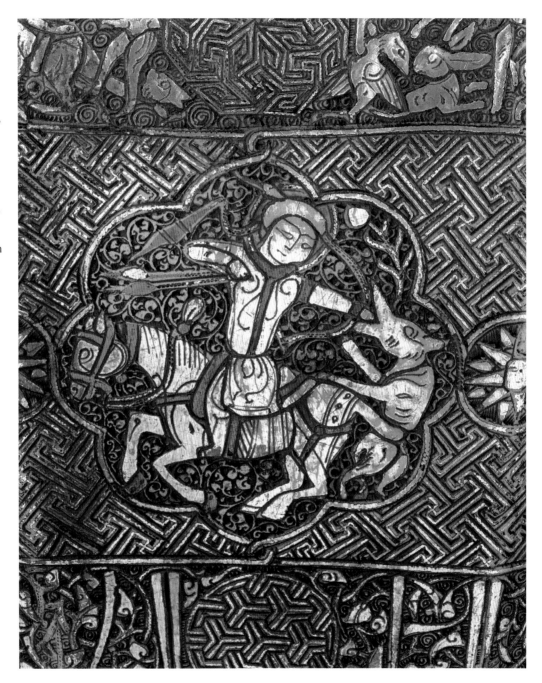

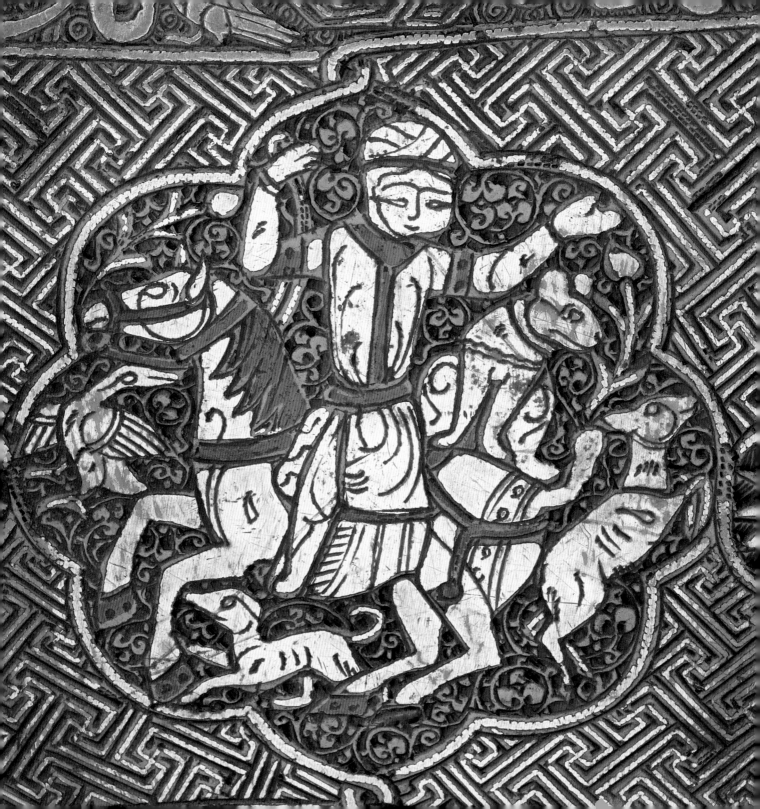

Two details from the 'Blacas' ewer.

Left: The mounted hunter is accompanied by his trained cheetah, riding on the horse's rump. Used for hunting since antiquity, cheetahs were expensive to train and maintain and demanded great patience on the part of their keepers. While a small hound runs next to the horse, the cheetah is ready to pounce on the leaping deer behind.

Above: A kneeling archer aims at a duck – two others appear to have fallen already.

7
War

War and the spread of Islam went hand in hand after the death of Muhammad in 632. His first successor, Abu Bakr (r. 632–4), one of the earliest converts to Islam, united Arabia under the banner of the faith and invaded southern Iraq and Palestine. During the next decade, the second caliph (literally, 'successor'), ʿUmar, and his Muslim forces overcame the Byzantines in Egypt and the Sasanians in Iraq and western Iran. The third and fourth 'Rightly Guided Caliphs', Uthman and ʿAli, Muhammad's cousin and son-in-law, were both assassinated by members of dissident factions who disagreed with the shape and direction of Muslim society that these leaders had chosen. Civil war ensued and the Shiʿat ʿAli (Party of ʿAli) was born. This group believed the leader of the Muslims should be descended from Muhammad through his daughter Fatima or her husband, ʿAli. Those who disagreed with this view, who came to be called Sunnis, were willing to accept a ruler who would maintain the unity of the Muslim faithful. This schism between Shiʿa and Sunnis has fuelled some (but by no means most) of the many wars fought by Muslims since 632.

Following the death of ʿAli in 661, the caliphate transferred to a cousin of the third caliph Uthman, from the Meccan family of Umayya. The Umayyads moved their capital to Damascus and remained in power until 750. They were then overthrown by rebels from north-eastern Iran, and the ʿAbbasid caliphate was born. With its capital at Baghdad and for a while at Samarra, the ʿAbbasid caliphate was supported by large numbers of Turkish soldiers. Often recent converts to Islam, these men could be rebellious and erode rather than protect the power of the caliph. By the 9th century the Turkish governor of Egypt, Ahmad ibn Tulun, had established his own semi-autonomous rule, and a local dynasty, the Samanids, governed Khurasan in north-eastern Iran. As more and more Central Asian Turks migrated into Iran and Iraq, a series of dynasties appeared and were then overthrown. All the while the ʿAbbasid caliphate carried on, although the real military and political power often lay in the hands of Turkish dynasts such as the Seljuks, who ruled in the 11th and 12th centuries.

A serious external threat to the central Islamic lands appeared in 1099 in the form of the Christian Crusaders from Europe. In 1100 they

Detail from the 'Blacas' ewer.
Two foot-soldiers do battle with straight-bladed swords and shields within a lobed medallion on the shoulder of the ewer. They may just be practising swordplay rather than actually fighting, since their clothes and armaments are very similar.

massacred whole populations of cities that would not submit to them, the Mongols became overstretched and lost control of Western Asia. To reassert themselves, Hulegu Khan and his army drove westwards and in 1258 defeated an ʿAbbasid army, killing the caliph Mustaʿsim. They were finally stopped in Palestine in 1260 by the Mamluks, but this defeat at the hands of the infidel and the resultant destruction of the caliphate dealt the Muslims an enormous psychological blow. In 1295 the Mongol leader Ghazan Khan converted to Islam, and until 1335, when the last powerful Mongol ruler in Western Asia died, they oversaw a literary and artistic renaissance. Stories of their conquests and political advances were recorded in a history of the world that was intended for distribution throughout their empire.

Historical texts such as the *Zafarnameh* or Book of Victories recount the military successes of Timur (Tamerlane) in the late 14th and early 15th centuries. Illustrated versions of this text not only glorify Timur's leadership but also reveal the technology he used for sieges and battles. By the 16th century, gunpowder had revolutionized war in the Islamic world. The Ottoman Turks fought with cannons and defeated the Safavid Iranians in 1514, and the Mughals in the 17th century could also claim superior firepower in their battles to unite India. Artists in each era included the armaments of the day in their depictions of war.

took Jerusalem, and over the next 70 years their territory in the eastern Mediterranean waxed and waned until, in 1187, Saladin defeated them at the battle of Hattin and retook Jerusalem. Among those who fought the Crusaders in the 12th century were the Atabegs of Mosul, a centre of inlaid metalworking in the early 13th century. On the objects made in Mosul are depicted pairs of figures fighting with swords and shields or jousting on horseback.

The most destructive force ever to fight and conquer the Muslims were the Mongols. After their invasion of Iran in 1220, when they

Bottom of a penbox, western Iran, signed by Mahmud ibn Sunqur, dated AH 680/AD 1281. Cast brass inlaid with silver and gold.

Whereas the lid of this penbox (see chapter 3) is decorated with personifications of the zodiac and planets, this surface contains two scenes of confronted horsemen, with hunters on the left and warriors on the right. The combatants hold long lances on the diagonal as their horses canter towards one another. Even if they are only jousting for sport, such activities were a preparation for battle in which spears, swords, bows and arrows and other light arms were all employed.

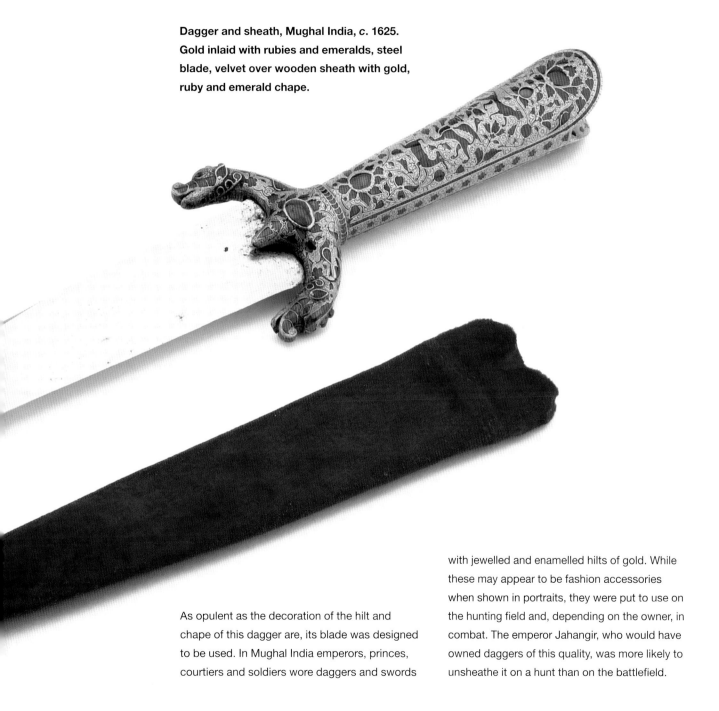

Dagger and sheath, Mughal India, *c.* 1625. Gold inlaid with rubies and emeralds, steel blade, velvet over wooden sheath with gold, ruby and emerald chape.

As opulent as the decoration of the hilt and chape of this dagger are, its blade was designed to be used. In Mughal India emperors, princes, courtiers and soldiers wore daggers and swords with jewelled and enamelled hilts of gold. While these may appear to be fashion accessories when shown in portraits, they were put to use on the hunting field and, depending on the owner, in combat. The emperor Jahangir, who would have owned daggers of this quality, was more likely to unsheathe it on a hunt than on the battlefield.

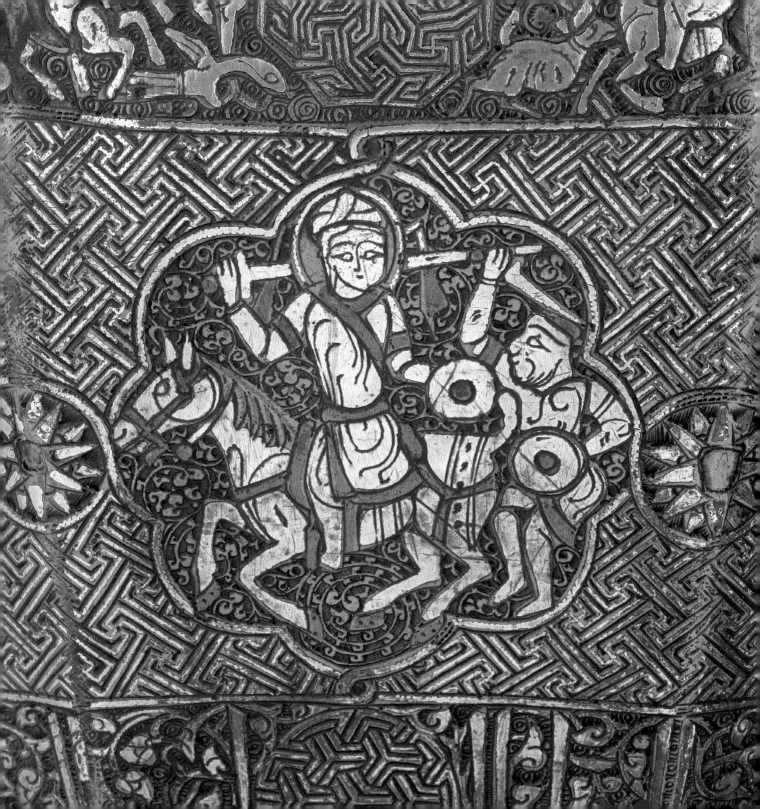

Left: Detail from the 'Blacas' ewer.

This detail from the body of the ewer depicts a horseman battling a foot-soldier. They hold identical shields, but the foot-soldier's short sword is no match for the horseman's long straight blade.

Detail from the 'Vaso Vescovali', lidded bowl.

The figures in this roundel represent the zodiacal sign Aries, the ram, ridden by the planet Mars. In keeping with his warlike identity, Mars holds a sword in one hand and a severed head in the other.

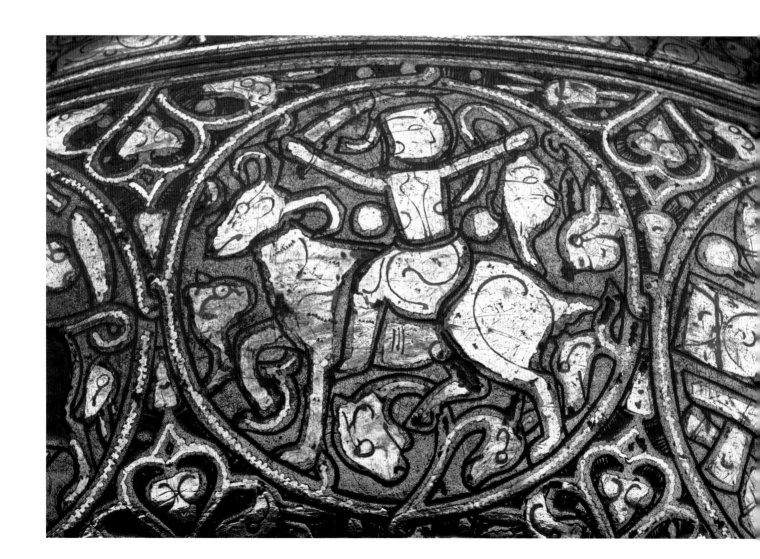

**'Massacre following the destruction of the tomb of Husayn at Karbala',
from a dispersed *Ta^crikh-e Alfi* (History of the Millennium) manuscript,
Mughal India, *c*. 1595. Opaque watercolour, gold and ink on paper.**
To commemorate the first millennium of Islam in 1591–2, the Mughal
emperor Akbar commissioned an illustrated history. This scene portrays the
massacre which took place after the ^cAbbasid caliph al-Mutawakkil (822–61)
ordered the destruction of the tomb of the Shi^ca martyr Husayn at Karbala in
Iraq, illustrated on the recto side of this folio. The dramatic bloodletting and
rushing figures are typical of the painting of Akbar's reign (1556–1605).

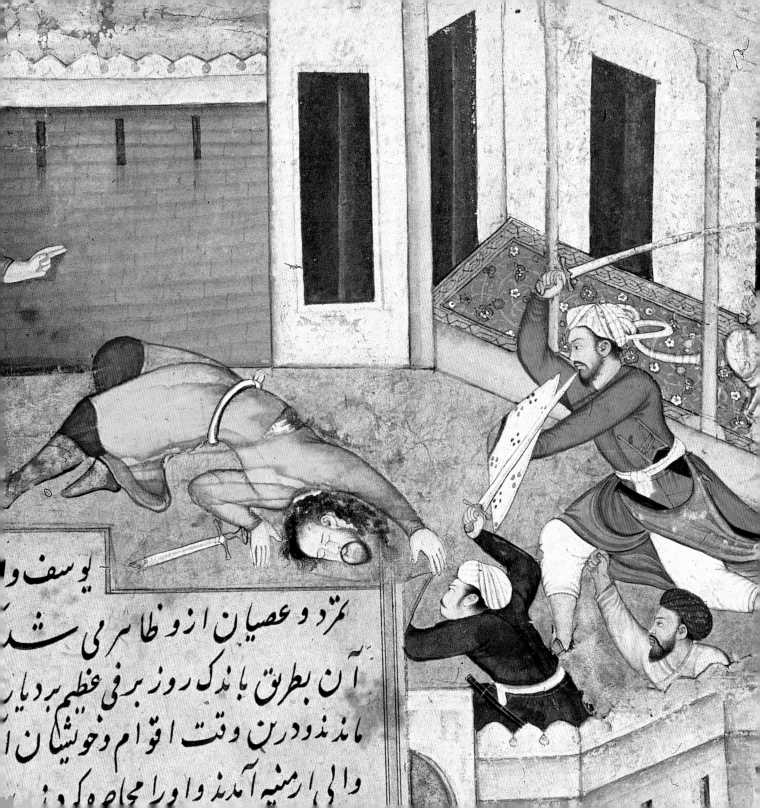

يوسف و

نمرد و عصيان ازو ظاهر مى ش

آن بطريق باندك روز برفى عظيم برديار

ماندند و درين وقت اقوام و خويشان ا

والى ارمنيه آمدند و اورا محاصره كر

8
Music

Music has perennially inspired Islamic artists to depict musicians and dancers in all media, and they play a significant role in the cycle of courtly images that also includes drinkers, hunters, warriors and enthroned potentates. Dancing women appear on the walls of the bath at the 8th-century palace of Khirbat al-Mafjar in Jordan and on the sides of late Sasanian and early Islamic silver bottles from Iran. Musicians adorn a 10th-century ivory pyxis (container for precious scents) from Islamic Spain, while an elegant dancer appears in an 11th-century Fatimid Egyptian ivory plaque. Enthroned figures in 12th-century ceramics from Seljuk Iran are seldom without their court musicians, just as inlaid metalwares from 13th-century Mosul and Damascus incorporate both musicians and dancers.

Whenever princes, kings and other notables held picnics or parties, musicians serenaded them, singing and playing lutes and tambourines. Dervishes are often portrayed playing stringed instruments at such gatherings, and some scenes of dancing dervishes include drummers and pipers. In addition to music performed at social occasions, figures playing kettle drums and blowing large horns often appear in battle scenes. In India, with its strong tradition of portraiture, court artists depicted renowned musicians. The fame (and some of the songs) of those who founded specific musical styles have endured to this day.

Musicians in the Islamic world played a variety of instruments. These include stringed instruments such as plucked and bowed lutes and harps as well as drums, castanets, tambourines, horns and pipes. All show regional variations in form, reflecting different musical styles. A 10th-century Arab treatise on music theory classifies the instruments, according the highest status to those that most closely approximate the human voice. Both men and women played musical instruments, sang and danced.

Although Muhammad himself did not object to music and singing, the 'Four Rightly Guided Caliphs' who succeeded him apparently took a dim view of music. In the strictest religious schools music was forbidden and many treatises condemn it, despite medieval scholars pointing out that

Rabab player, Safavid Iran, Qazvin, signed by Muhammad Ja^cfar, c. 1590. Opaque watercolour and gold on paper. After the death of Shah Tahmasp in 1576, musicians who had been banned from the Safavid court were invited to return. From this time on many artists produced single-page paintings and drawings of musicians, alone or in groups.

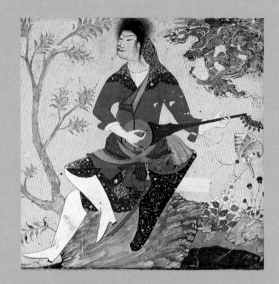

the chanting of the Qur'an was actually a form of singing. Yet court patronage continued and urban elites employed singing girls and professional male singers to perform art songs in their homes. These songs were reportedly accompanied by the ^cud, a short-necked lute.

Early and medieval Islamic writing on the subject of music falls into two main categories: treatises on music theory and texts dealing with song or music in the practical sense. From the 8th to the 11th century authors gathered collections of popular songs, the best known being the *Book of Songs* (*Kitab al-Aghani*) of al-Isfahani. Unfortunately, these compilations do not indicate the sound of the music: methods of notation were devised by theorists but not used by musicians. The terminology of the treatises reveals a sophisticated understanding of

distinctions in vocal and instrumental techniques and modal and rhythmic structures.

Another form of music applies specifically to Sufi mystics. Called *sama^c*, meaning 'hearing' or 'that which is heard', it implies the hearing of music which can produce an ecstatic state in the mystical listener. In addition to chanting of the Qur'an and prayers, *sama^c* can include the singing of secular poetry in which odes to the loved one are metaphors for the love of God or his prophet Muhammad. Over time, the performance of *sama^c* expanded from singing (with or without instrumental accompaniment) to include dancing, followed by a meal. Some clerics and Islamic jurists frowned upon *sama^c*, suspecting it was more of a sensual delight than an aid to spiritual ecstasy. Nevertheless, its popularity continued unabated and restrictions placed upon it took the form of discouraging the use of certain instruments in favour of others such as tambourines and the *ney*, a type of flute. In practice, *sama^c* is often performed in the context of *dhikr* – the repetition of words or phrases to induce concentration on God. Numerous 16th- and 17th-century Persian and Mughal paintings and drawings of dervishes singing and dancing must be interpreted as representations of *sama^c*.

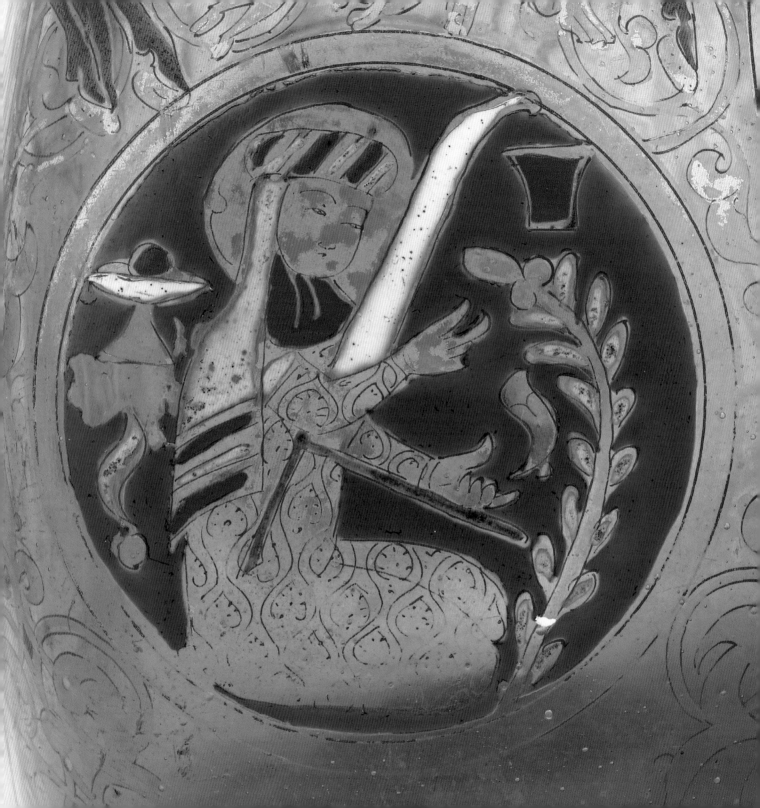

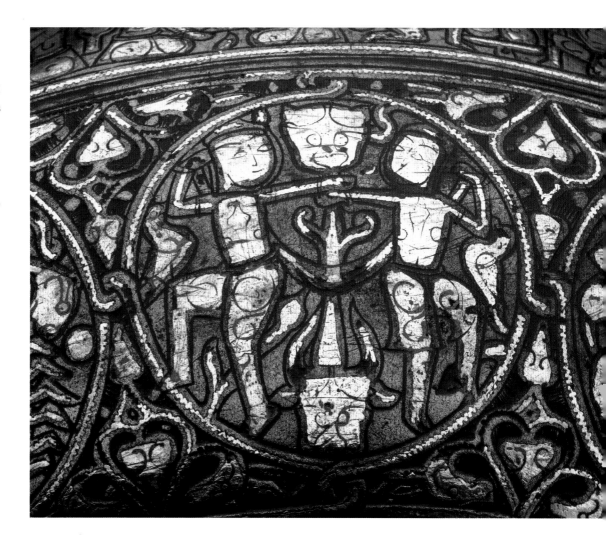

Left: Detail of a pilgrim bottle.
The elegant lady harpist wearing a veil beneath her turban is a fixture in the cycle of courtly images found on much medieval Islamic metalwork and glass. A beaker of red wine and a platter of fruit seem to float in the space around her.

Detail of the 'Vaso Vescovali', lidded bowl.
The zodiacal sign Gemini is personified by two dancing twins whose bodies turn outwards but whose heads incline inwards towards the symbol of the planet Mercury – a staff with two masks representing the pseudo-planets that were thought to cause eclipses. The twins either join hands or both clasp the central staff while bending their outer arms back and extending a cloth between them. Even in astrological contexts, music and dance infused the depiction of the planets and zodiacal signs.

Below: Detail of the penbox.

In a small medallion on the side of the penbox, a dancer swings his long sleeves to the rhythm of music, which may emanate from the tambourinist in a medallion to the left of the hasp.

Right: Detail of the 'Blacas' ewer.

The harp and *ney*, a small flute played like a recorder, often accompany one another. Here the ornamentation of the harp and its termination in a bird's head indicate the importance accorded to music within the courtly setting.

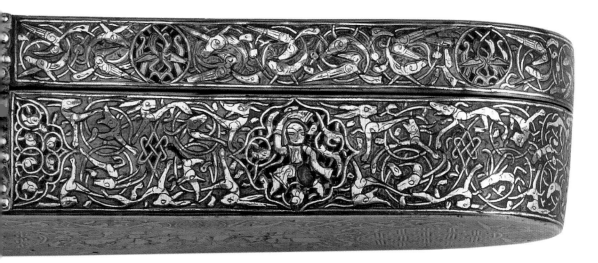

Detail of the 'Vaso Vescovali', lidded bowl.

A harpist and drinker appear in a band just below the rim of the bowl. Unlike many illustrations of the harp on metal and glass objects, here the strings have been included.

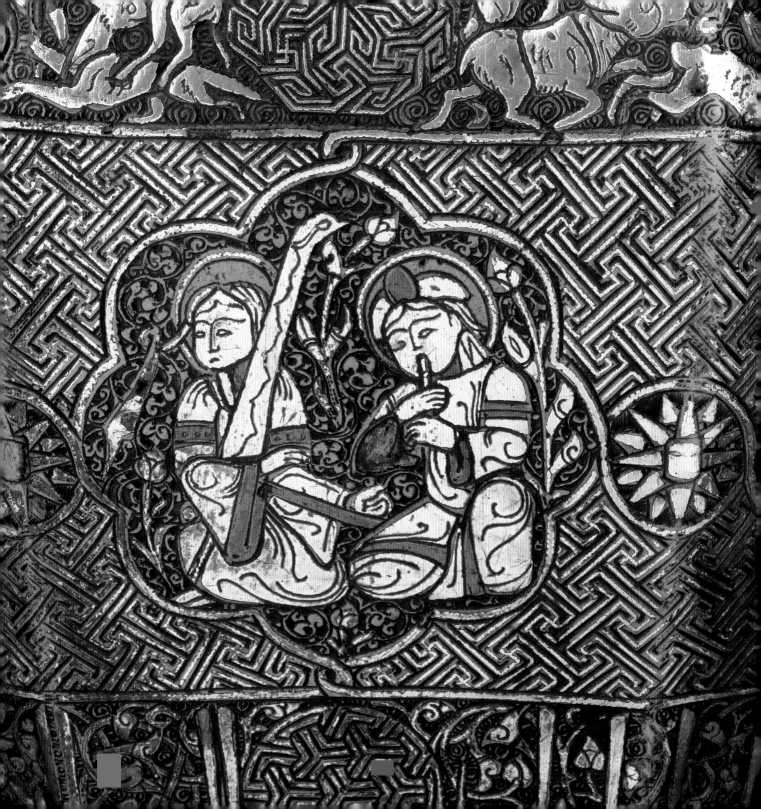

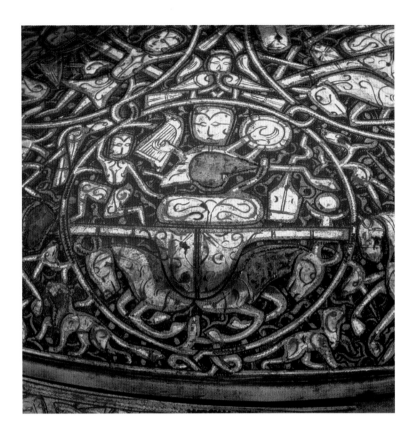

Right: Detail of a rabab player, Safavid Iran, Qazvin, signed by Muhammad Ja‘far, *c*. 1590. Opaque watercolour and gold on paper.

The soundbox of this *rabab* is covered with skin died green, while the wooden 'shoulder' at the base of the neck is decorated with roundels of inlaid mother-of-pearl or ivory and ebony. Played with a long pick, the *rabab* appears to have two black strings and four white ones. The vegetation and swirling clouds heighten the romantic impression made by this young dandy, who has stopped to play a tune.

Detail of the 'Vaso Vescovali', lidded bowl.

Personifying the planet Venus, this multi-armed figure is a veritable one-woman band. She plays the harp, lute and tambourine, while another stringed instrument stands near a bowl of fruit at the right. A dancer poses at the left.

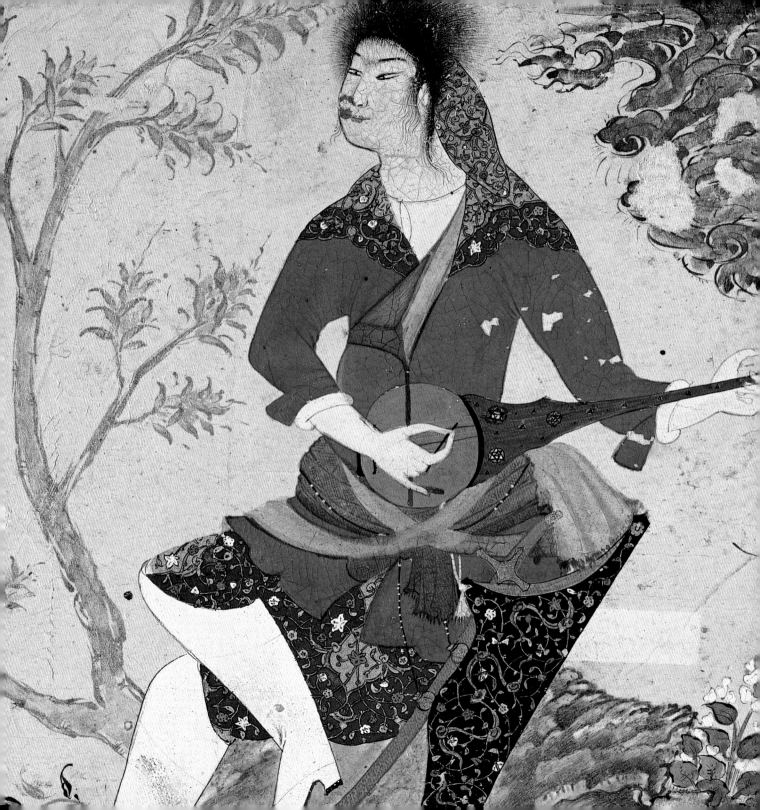

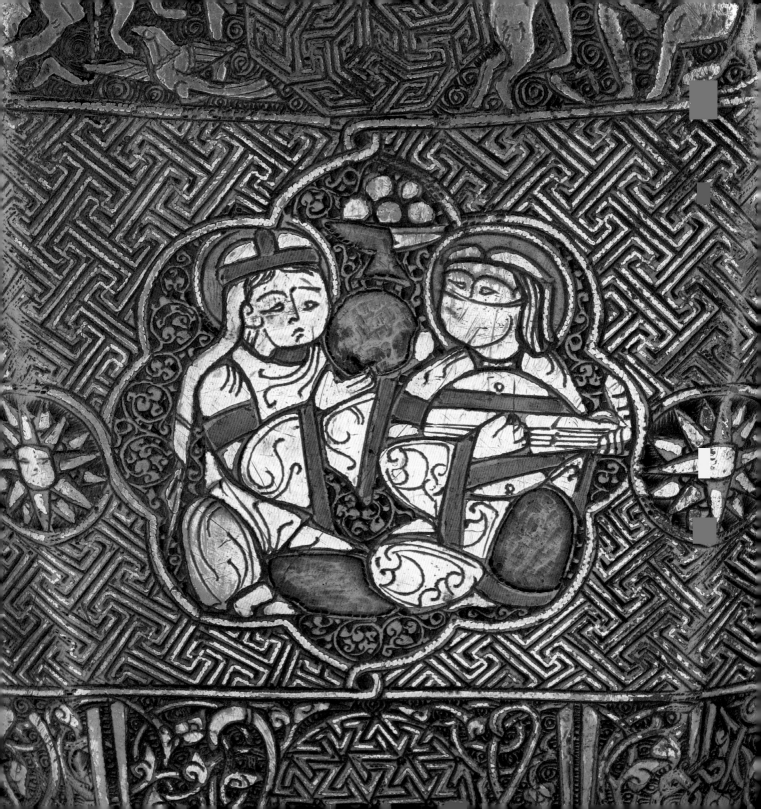

Details of the 'Blacas' ewer.
Left: Of particular interest in this representation of a pair of musicians who play the tambourine and the lute is the identification of both figures as women. Furthermore, the veiled face of the lutanist is quite unusual and may imply that she was of high social status.

Right: Beside a small medallion of a lutanist on the neck of the ewer appears this figure of a dancer, who sports an animal-headed mask and a long tail.

9
Power

The ubiquitous phrase in Islamic art and architecture, 'al-mulk lillah', 'the dominion is God's', admits no doubt as to the primary source and seat of power in the world: it is God. Nonetheless, the history of the Islamic world has revolved around powerful individuals, starting with Muhammad. While the early caliphs derived their power – in theory if not in practice – from the consensus of the Muslim faithful, *de facto* power was often held by military leaders or other 'clients' of the caliphs.

With the fall of the caliphate to the Mongols in 1258, the pretence of worldly and spiritual authority vested in the caliph collapsed. The name of the conqueror Genghis (Chingiz) Khan resonates to this day, attesting to his utter domination of the lands from China to Iran. Only Timur (Tamerlane) in the late 14th and early 15th century would come close to holding as much territory. Interestingly, one dynasty, the Mamluks, was successful in resisting both the Mongols and the Timurids. While a few of the freed Turkish slaves (the word 'mamluk' means slave) who rose to the rank of sultan in Egypt and Syria held the reins of power for several years, if not decades, many

ruled very briefly and were overthrown or assassinated by their rivals.

In the early 16th century three dominant dynasties – the Ottomans, Safavids and Mughals – controlled the lands from Egypt to northern India. An omnipotent sovereign ruled each of these dynasties, supported by armies and administrators as well as members of their own families. The pyramidal structure of political power was topped by the sultan, shah or emperor. As for spiritual power, the Ottoman sultan considered himself the heir to the caliphate, a claim reinforced by his control of Mecca and Madina. The Safavid shah, as heir to the shaykhs of an important dervish order at Ardabil in north-western Iran, also asserted his spiritual leadership. As ruler of a heterodox population, the religious role of the Mughal emperor was less clear-cut than that of his Turkish and Iranian counterparts, but this did not diminish his power to determine the course of spiritual affairs in his own realm.

Power is represented in a variety of forms in Islamic art. Inscriptions, long and short, on buildings and objects of all kinds proclaim the power of God, the power of kings, and power

Detail of the 'Vaso Vescovali'.
The king of beasts makes many appearances in Islamic art but here the lion represents Leo as the domicile of the sun, his planet-lord. This motif eventually became the emblem of the 19th-century Qajar dynasty of Iran.

What do these types of inscription mean when they appear on objects without an attribution to a royal or other specific patron? For example, a 12th-century glazed Persian ceramic bowl with moulded decoration forming the words 'power, prosperity and dominion' includes the name of the maker but not the name of a patron. Presumably the bowl was not commissioned by a specific person, but whoever bought it was satisfied with the message its inscription conveyed. It is impossible to know whether the owner perceived any irony in possessing an object made of a humble material but bearing words usually associated with potentates. Certainly an evolution of royal titles occurred throughout the Islamic world, and we must assume that their use in civilian contexts was intended to communicate positive ideas.

The imagery of power in Islamic art incorporates a range of symbols in addition to epigraphy. Enthroned or crowned figures symbolize kings or amirs, princes who ruled within larger kingdoms. While often these figures are depicted frontally on their thrones, some substantial personages merely receive the offerings of subordinate figures, who may be servants or social inferiors. Certain pre-Islamic kings achieved near-mythical status and thus can be recognized by their iconography when they appear on metalwork and ceramics. In these instances, the imagery suggests power by association with the well-known ruler.

alone. Thus the early caliphs were referred to as 'amir al-muʿminin', 'Commander of the Faithful', in foundation inscriptions, milestones and other official constructions. With the passage of time the number of rulers' honorific titles increased, so that an inscription with the name of the Mamluk sultan Baibars on the Citadel of Damascus from 1261 includes the following: 'In the name of God ... Glory to our master the sultan the king az-Zahir, pillar of the state and of the faith, the sage, the just, the warrior of the frontier, the strengthener, the victorious Baibars ...' Royal titulature on both architecture and objects is invariably an assertion of the power of the king.

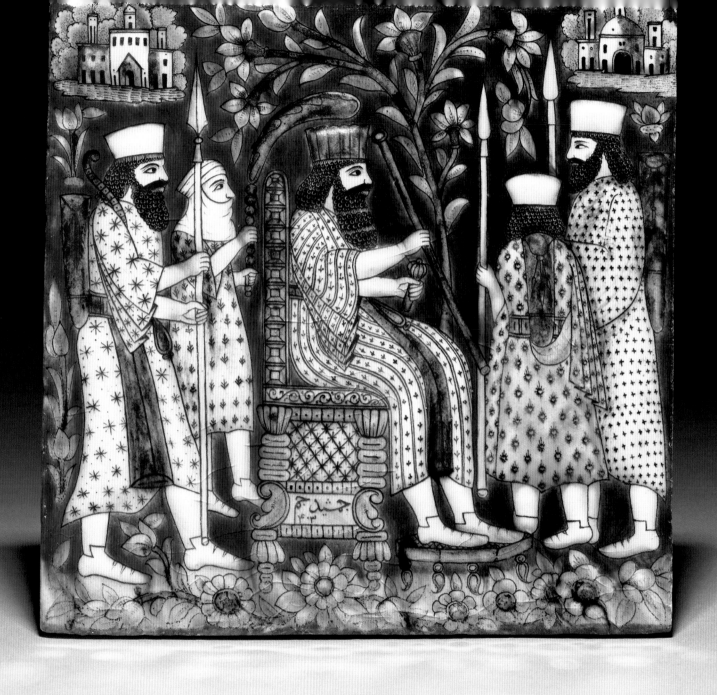

Rectangular tile, Qajar Iran, late 19th century. Ceramic moulded stonepaste body, blue, black, turquoise, brown and pink underglaze and transparent glaze.

Inscribed 'Jamshid the King', this tile portrays the legendary Iranian king Jamshid, the fourth king of the *Shahnameh* (the Persian national epic), with armed attendants and a veiled servant. He is dressed here as an Achaemenid king and seated on the type of throne that appears in the reliefs at Persepolis, capital of the Achaemenid empire (550–330 BC). In the 19th century the Qajars revived the symbols of Achaemenid Iran in order to aggrandize the image of their dynasty.

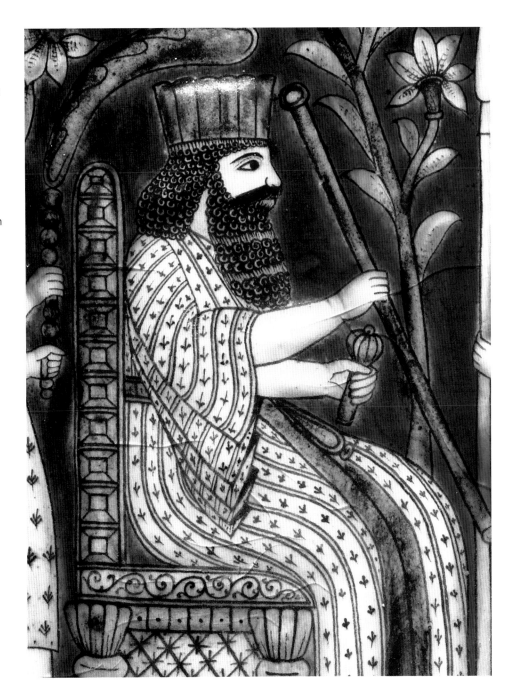

Right: Two details of the 'Vaso Vescovali', lidded bowl.

These two roundels contain seated figures representing the pseudo-planet Draco, the dragon (right), and the planet Jupiter (far right). Draco derives its power from 'eating' the sun and causing an eclipse. One of Jupiter's attributes is an inscribed banner, of which the first word appears to be 'power'.

Jade bowl with dragon-shaped handle, Central Asia or China, c. 1420–29.

Made in either Samarkand or China, this bowl is inscribed with the name 'Ulugh Beg', the third Timurid emperor. Jade objects were thought to be powerful antidotes to poison and thus necessities for rulers.

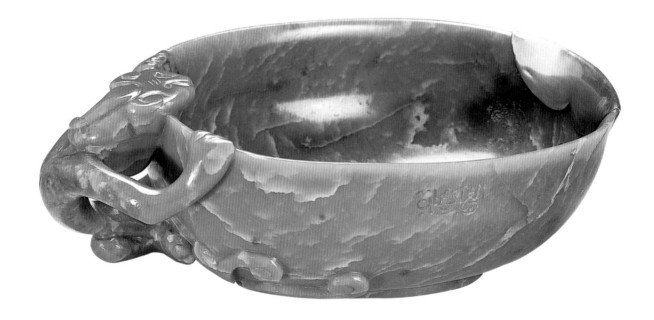

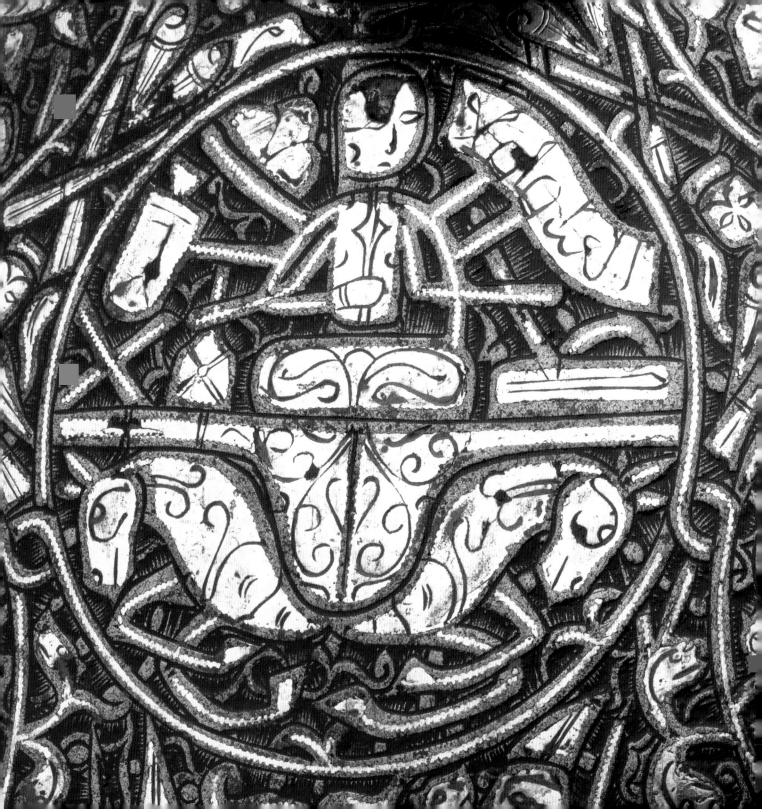

Details from 'Prince Khurram weighed against gold, silver and other metals', from a dispersed *Jahangirnama*, Mughal India, *c*. 1618. Opaque watercolour, ink and gold on paper.

Right: The Mughal emperor Jahangir (r. 1605–27) steadies the rope of the tray of a jewel-studded scale in which his son Prince Khurram is seated. After the royal Mughal astrologers had predicted that 'a most important epoch according to his horoscope would occur', Jahangir ordered that this weighing should take place on the prince's 16th birthday. The total number of coins that equalled his weight were then distributed to holy men and the needy.

Above: Textiles and jewelled items presented by courtiers and grandees were also laid before this prince of the rich and powerful Mughal dynasty.

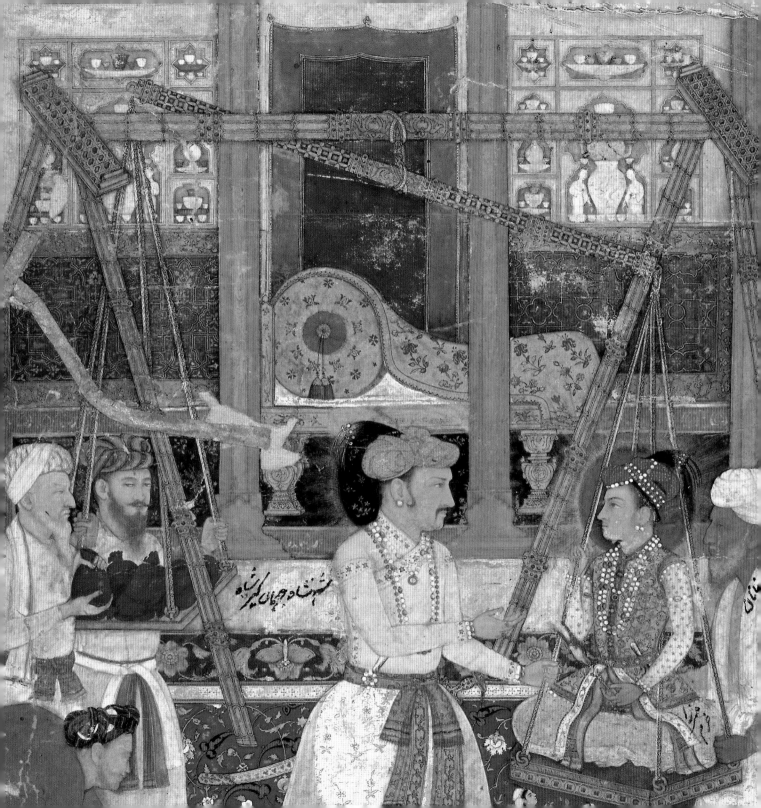

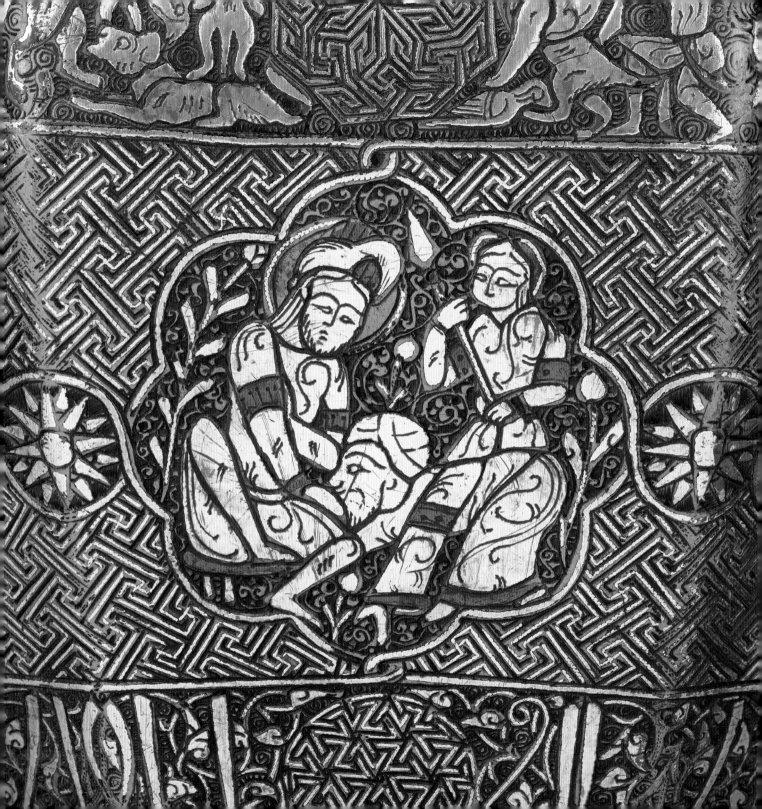

Details from the 'Blacas' ewer.

Left: A bearded figure bows deeply to kiss the hand of a potentate seated on a low stool while an attendant with a spear stands guard. The pose of the seated figure resembles that of governors in two separate manuscripts of the 1220s and 1230s, suggesting that this figure may also be a governor. Although these scenes are described in texts, depictions of people paying such deep obeisance are rare but reflect the broad range of 13th-century Mosul metalwork.

Above: A seated archer receives a flagon proffered by a servant with hunched shoulders. Even in this tiny medallion, the subtle details of the servant's pose and the relative size of the figures indicate who is dependent upon whom.

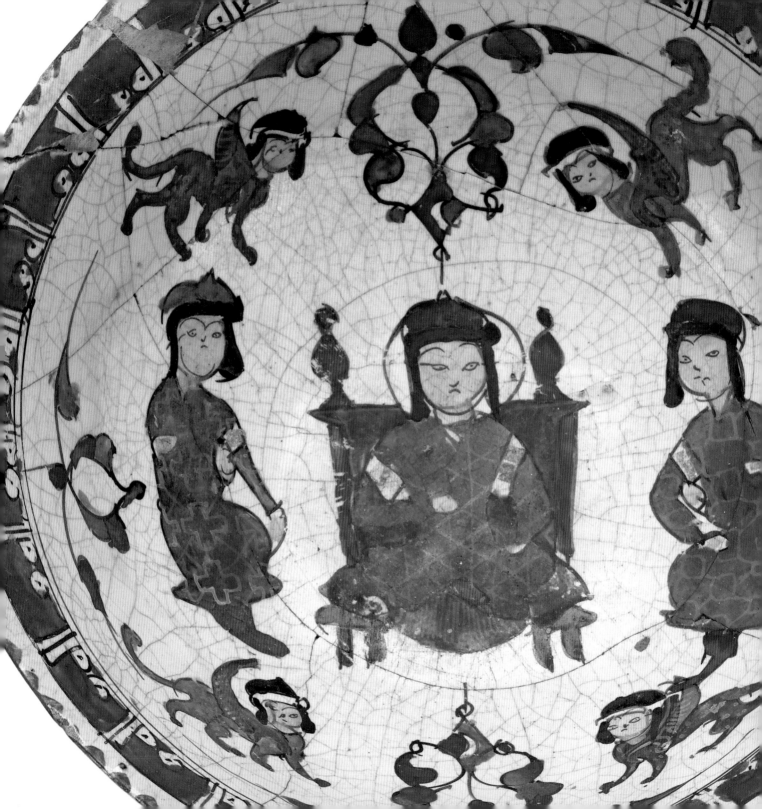

Mina'i ware bowl, Iran, late 12th–early 13th century.
Ceramic stonepaste body, overglaze and underglaze painting
and transparent glaze.

The enthroned ruler with attendants and sphinxes is a perennial symbol of power which appears across the full range of media in Islamic art. Here the two pairs of sphinxes above and below the attendants must denote generally positive associations but may also relate to the cosmic belief system evident on inlaid brasses decorated with planetary and astrological representations (see chapter 3). While those symbols are auspicious, they also embody the possibility of the opposite – if supernatural creatures can protect just kings, they can also work against the unjust.

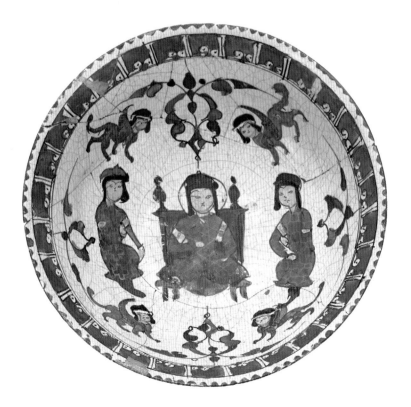

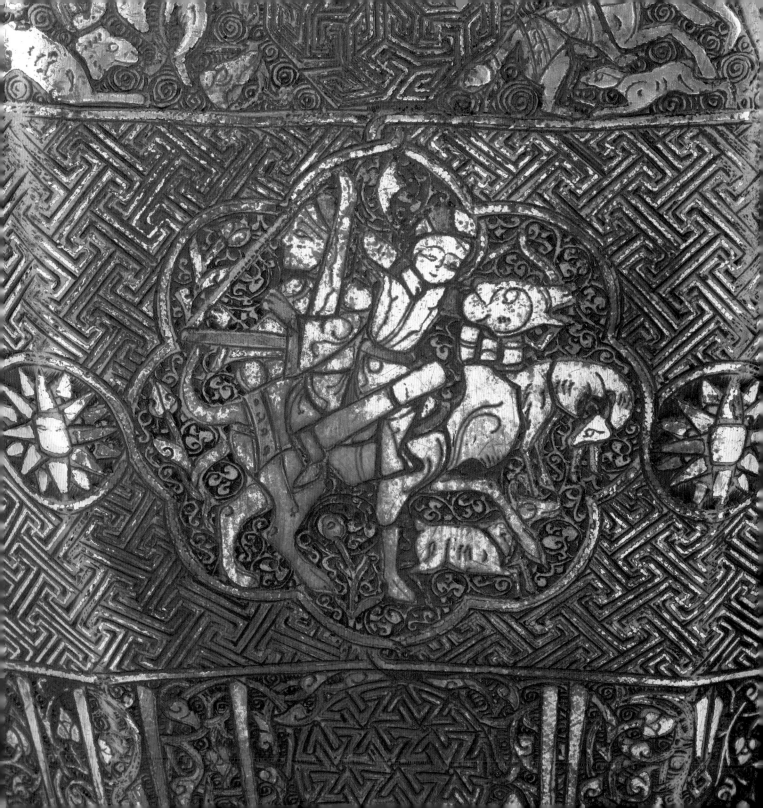

Left: Detail from the 'Blacas' ewer.

The figures in this medallion represent Bahram Gur, the famous king of Sasanian Iran, and his slave-girl Azadeh. Known for his hunting prowess, the king took Azadeh with him on his camel as he hunted for deer. As she strummed her harp, he grazed a deer's ear with one arrow and then, as it raised its hoof to scratch, he used another to pin the hoof to the ear. Azadeh accused him of practising black magic and so angered him that he threw her from their mount and trampled her to death – exercising his royal power in the most extreme way.

Right: Detail from a carved ivory panel, Mamluk Egypt, 14th century.

The crown on this figure's head identifies him as a royal personage. He may also be holding an orb in his right hand, another symbol of royalty more often associated with Christians or Europeans than with Muslims.

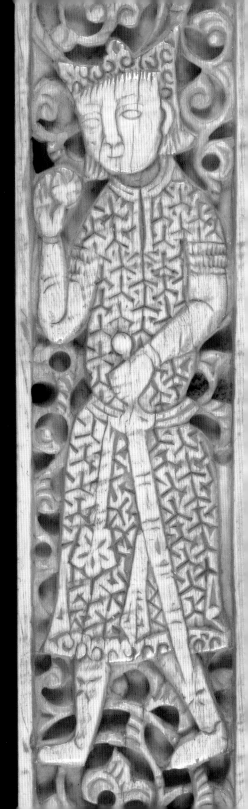

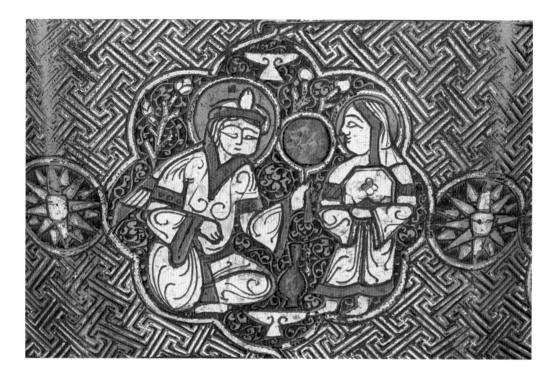

Right: This woman riding in a litter on a camel, with a guide walking before and a bearded servant riding behind her, is another depiction of a wealthy and presumably powerful female.

Details from the 'Blacas' ewer.

Male kings, princes and other grandees did not have a monopoly on power in the medieval or later Islamic world. Women also ran households, inherited wealth and influenced dynastic succession, and they purchased expensive textiles, cosmetics and perfumes to dress and present themselves.

Above: The woman at the left in this medallion scrutinizes herself in the mirror she holds in her left hand while her servant stands expectantly by: a scene that must reflect aristocratic life in 13th-century Mosul but which also rings true today.

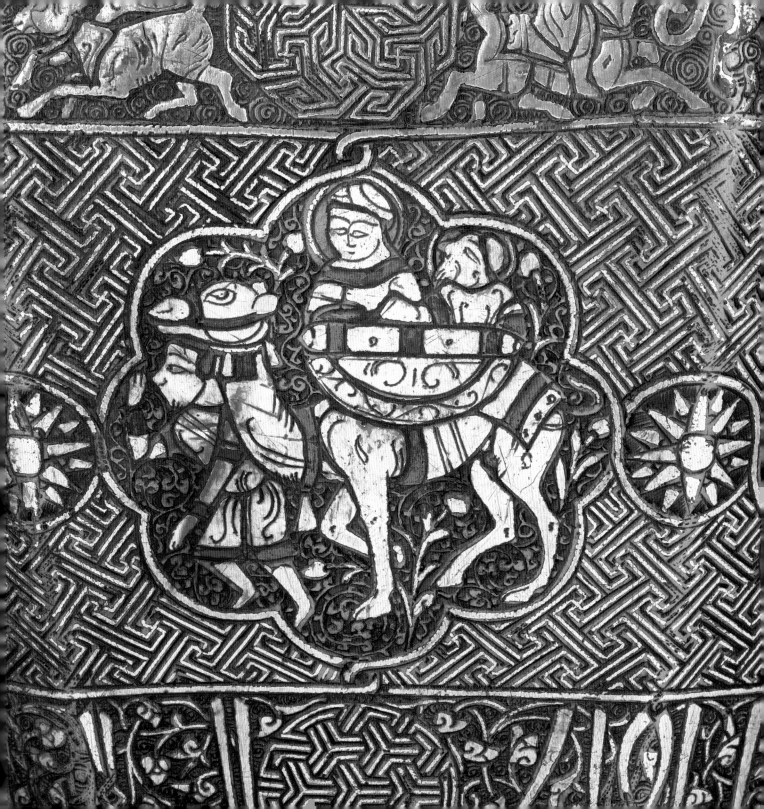

10
Further information

FURTHER READING

Islamic art in general

S. Blair and J. Bloom, *The Art and Architecture of Islam 1250–1800*. Yale/Pelican History of Art, 1994

R. Ettinghausen and O. Grabar, *The Art and Architecture of Islam 650–1250*. Penguin, 1987

R. Ettinghausen, O. Grabar and M. Jenkins-Madina, *Islamic Art and Architecture 650–1250*. Yale/Pelican History of Art, 2001

O. Grabar, *The Formation of Islamic Art*. Yale, 1987

R. Hillenbrand, *Islamic Art and Architecture*. Thames & Hudson, 1999

R. Irwin, *Islamic Art: Art, architecture and the literary world*. Laurence King, 1997

Islamic ornament and decoration

T. Allen, *Five Essays on Islamic Art*. Solipsist Press, 1988

E. Baer, *Islamic Ornament*. Edinburgh University Press, 1998

E. Baer, *Sphinxes and Harpies in Medieval Islamic Art: An iconographical study*. Israel Oriental Society, 1965

M. Dimand, 'Studies in Islamic Ornament – I: Some Aspects of Omaiyad and Early ^cAbbasid Ornament'. *Ars Islamica*, vol. IV, 1937, pp. 293–337

O. Grabar, *The Mediation of Ornament*. Princeton, 1992

O. Jones, *The Grammar of Ornament*. Studio Editions, 1986

G. Necipoglu, *The Topkapi Scroll – Geometry and Ornament in Islamic Architecture*. Getty Center Publication, 1995

Y. Petsopoulos, *Tulips, Arabesques and Turbans: Decorative arts from the Ottoman Empire*. Alexandria Press, 1982

J. Trilling, *The Language of Ornament*. Thames & Hudson, 2001

Islamic inscriptions

S. Blair, *Islamic Inscriptions*. Edinburgh University Press, 1998

M. U. Derman and N. M.Çetin, *The Art of Calligraphy in the Islamic Heritage*. IRCICA Istanbul, 1998

W. Hanaway and B. Spooner, *Reading Nasta^cliq*. Mazda, 1995

Y. H. Safadi, *Islamic Calligraphy*. Thames & Hudson, 1978

A. Schimmel, *Calligraphy and Islamic Culture*. I. B. Tauris, 1990

A. Schimmel, 'Islamic Calligraphy'. *Metropolitan Museum of Art Bulletin*, Summer 1992

A. Welch, *Calligraphy in the Arts of the Muslim World*. Dawson & Sons, 1979

Decorative arts and crafts

N. Atasoy and J. Raby, *Iznik: The pottery of Ottoman Turkey*. Alexandria Press, 1989

E. Atil, *Ceramics from the World of Islam*. Smithsonian Institution, 1973

E. Atil, *Metalwork in Medieval Islamic Art*. State University of New York Press, 1983

M. C. Beach, *The Imperial Image: Paintings for the Mughal court*. Freer Gallery of Art, Smithsonian Institution, 1981

S. Carboni, *Glass from Islamic Lands*. Thames & Hudson, 2001

R. Ettinghausen, *Arab Painting*. Skira, 1977

G. Fehervari, *Pottery of the Islamic World in the Tareq Rajab Museum*. Tareq Rajab Museum, 1998

W. Hartner, 'The Vaso Vescovali in the British Museum: A Study in Islamic Astrological Iconography'. *Kunst des Orients* 9, no. 1–2 (1973–4), pp. 99–130

A. Lane, *Early Islamic Pottery*. Faber, 1947

A. Lane, *Later Islamic Pottery*. Faber, 1957

A. S. Melikian-Chirvani, *Islamic Metalwork from the Iranian World, 8th–18th century*. HMSO, 1982

E. Sims, *Peerless Images: Persian painting and its sources*. Yale, 2002

O. Watson, *Ceramics from Islamic Lands*. Thames & Hudson, 2004

O. Watson, *Persian Lustre Ware*. Faber, 1985

S. C. Welch, *Imperial Mughal Painting*. Braziller, 1978

Exhibition catalogues

Arts of Islam. Arts Council of Great Britain, 1976

S. Carboni and D. Whitehouse, *Glass of the Sultans*. Yale, 2001

Institut du Monde Arabe, *L'Orient de Saladin: L'art des Ayyoubides*. Gallimard, 2001

L. Komaroff and S. Carboni (eds), *The Legacy of Genghis Khan: Courtly art and culture in Western Asia, 1256–1353*. Yale, 2002

T. W. Lentz and G. D. Lowry, *Timur and the Princely Vision*. Los Angeles County Museum of Art, 1989

V. Porter, *Mightier than the Sword*. Ian Potter Museum of Art, Melbourne, 2003, Islamic Arts Museum Malaysia, 2004

D. J. Roxburgh (ed.), *Turks: A journey of a thousand years, 600–1600*. Royal Academy of Arts, 2005

J. Seyller, E. Koch and W. Thackston, *The Adventures of Hamza*. Azimuth Editions, 2002

J. Thompson and S. R. Canby (eds), *Hunt for Paradise: Court arts of Safavid Iran, 1501–76*. Skira, 2003

The *Encyclopaedia of Islam*, *Encyclopaedia Iranica* and *Macmillan Dictionary of Art* have extremely useful articles on individual artists, architecture, dynasties etc.

Sources of quotations in the text

Chapter 5
S. A. Yazdi, 'Zafarnama', in W. Thackston, *A Century of Princes*. Aga Khan Program in Islamic Architecture, 1989: p. 97.

Chapter 9
Jahangir, *The Tuzuk-i Jahangiri; or Memoirs of Jahangir*. A. Rogers (trans.), H. Beveridge (ed.), London, 1909–14: vol. 1, p. 115.

British Museum Press publications

P. L. Baker, *Islamic Textiles*. 1995

B. Brend, *Islamic Art*. 1991

S. R. Canby, *Persian Painting*. 1993

S. R. Canby (ed.), *Safavid Art and Architecture*. 2002

J. Carswell, *Iznik Pottery*. 1998

J. Cherry (ed.), *Mythical Beasts*. 1995

M. Ja'far, *Arabic Calligraphy: Naskh script for beginners*. 2002

V. Porter, *Islamic Tiles*. 1995

J. M. Rawson, *Chinese Ornament: The lotus and the dragon*. 1984

J. M. Rogers, *Islamic Art and Design*. 1983

J. M. Rogers, *Mughal Miniatures*. 1993

J. M. Rogers and R. M. Ward, *Suleyman the Magnificent*. 1988

R. Ward, *Islamic Metalwork*. 1993

R. Ward (ed.), *Gilded and Enamelled Glass from the Middle East*. 1997

S. Weir, *Palestinian Costume*. 1989

E. Wilson, *Islamic Designs*. 1988

British Museum collections and website

Many of the books listed on pp. 138–9 can be consulted in the Paul Hamlyn Library, a free-entry public reference library housed in the Reading Room in the Great Court. See:

www.thebritishmuseum.ac.uk/education/libraries/home.html/hamlyn

The Islamic section of the Department of Asia organizes exhibitions of works on paper alongside the permanent installation in the John Addis Islamic Gallery (Gallery 34) and occasional special exhibitions on aspects of Islamic art in the Museum's special exhibition galleries. To study the collection, apply in writing to the Department of Asia. Consult the Department website for further details:

www.thebritishmuseum.ac.uk/asia

The Department of Asia also holds ethnographic collections from the Middle East and Central Asia.

The Coins and Medals Department holds Islamic coins and banknotes. There are displays of money in the HSBC Money Gallery as well as in Gallery 34.

The Departments of Prehistory and Europe and of Africa, Oceania and the Americas hold examples of Islamic art from North Africa and combined with European mounts.

Access to most of the images reproduced in this book, including descriptions of key objects, is available digitally via:

www.thebritishmuseum.ac.uk/compass

OTHER COLLECTIONS IN THE UK

The Victoria and Albert Museum, London

V&A PUBLICATIONS

A. Contadini, *Fatimid Art at the Victoria and Albert Museum*. 1998

R. Crill, S. Stronge and A. Topsfield, *Arts of Mughal India: Studies in honour of Robert Skelton*. 2004

Y. Crowe, *Persia and China: Safavid ceramics in the Victoria and Albert Museum, 1501–1738*. La Borie, 2002

T. Stanley, M. Rosser-Owen and S. Vernoit, *Palace and Mosque: Islamic art from the Middle East*. 2004

S. Stronge, *Painting for the Mughal Emperor: The art of the book, 1560–1660*. 2002

V&A COLLECTIONS AND WEBSITE

In addition to collecting ceramics, glass and metalwork, like the British Museum, the V&A also acquires textiles, carpets and woodwork. For key objects, see:

www.vam.ac.uk

then click on 'Access to Images' or 'Asia'.

Other collections in the UK and Ireland, including libraries with Islamic manuscripts

Bradford: www.bradfordmuseums.org

Bristol: www.bristol-city.gov.uk/museums

Cambridge: Fitzwilliam Museum: www.fitzmuseum.cam.ac.uk

Dublin: Chester Beatty Library: www.cbl.ie

Durham: Oriental Museum: oriental.museum@durham.ac.uk

Edinburgh: www.nms.ac.uk

Glasgow: Kelvingrove, St Mungo's, Burrell Collection: www.glasgowmuseums.com

Leeds: Royal Armouries: www.armouries.org.uk

London:
British Library: www.bl.uk

Horniman Museum: www.horniman.ac.uk

Manchester:
www.manchestergalleries.org/index.html

www.man.ac.uk/museum

John Rylands University Library: http://rylibweb.man.ac.uk

Whitworth Art Gallery: www.whitworth.man.ac.uk

Oxford:
Ashmolean: www.ashmol.ox.ac.uk

Pitt-Rivers: www.prm.ox.ac.uk

OTHER COLLECTIONS
IN EUROPE, USA, MIDDLE EAST
AND ISLAMIC WORLD

Europe

Austria: Vienna, Museum für angewandte
Kunst: www.mak.at

Belgium: Brussels, Musées Royaux d'Art
et d'Histoire: www.kmkg-mrah.be

France: Paris, Musée du Louvre:
www.louvre.fr

Germany:
Berlin, Museum für Islamische Kunst:
www.smb.spk-berlin.de

Hamburg, Museum für Kunst und
Gewerbe: www.mkg-hamburg.de

Greece: Athens, Benaki Museum:
www.benaki.gr/collections/islamic/en

Netherlands: Leiden, National Museum
of Ethnology: www.rmv.nl

Poland: Krakow, National Museum:
www.krakow-info.com/museums

Portugal: Lisbon, Gulbenkian Foundation:
www.gulbenkian.pt

Russia: St Petersburg: State Hermitage
Museum: www.hermitagemuseum.org

Sweden: Gothenburg, World Culture
Museum: www.varldskulturmuseet.se

USA

Boston: Museum of Fine Arts:
www.mfa.org

Brooklyn Museum:
www.brooklynmuseum.org

Cambridge, MA: Sackler Museum,
Harvard University:
www.artmuseums.harvard.edu/sackler/

Chicago: Art Institute: www.artic.edu/

Cleveland Museum of Art:
www.clevelandart.org

Los Angeles County Museum of Art:
www.lacma.org

New York:
Asia Society: www.asiasociety.org

Metropolitan Museum of Art:
www.metmuseum.org

New York Public Library: www.nypl.org

Philadelphia Museum of Art:
www.philamuseum.org

San Francisco:
Asian Art Museum: www.asianart.org

www.search.famsf.org

Washington, DC:
Library of Congress:
www.loc.gov/exhibits/

Smithsonian Institution, Sackler Gallery
and Freer Gallery of Art: www.asia.si.edu/

Middle East and Islamic world

Iran:
Golestan Palace Museum:
www.goloctanpalaco.ir/

Tehran: Museum of Contemporary Art:
www.tmca-ir.org

Tehran: Reza Abbasi Museum:
www.rezaabbasimuseum.ir

Israel: Jerusalem:
Islamic Museum:
www.jerusalemites.org/jerusalem/islam

L. A. Mayer Museum for Islamic Art:
www.islamicart.co.il

Malaysia: Islamic Arts Museum:
www.iamm.org.my

Syria, Damascus: National Museum:
www.syriamuseum.com/damascus_museum

Although many national museums in Islamic
countries do not appear to have their own
websites, in 2007 the website of the
Euromed Heritage Project, 'Discover Islamic
Art', will be launched. This will consist of a
Virtual Islamic Museum which will include
Islamic objects and architectural sites from
around the Mediterranean as well as
museums in the UK, Germany and Sweden.
For information see:
www.euromedheritage.net/en/
euromedheritageprojects/eh3/discover.htm

Other useful websites:

http://archnet.org/library

www.artcyclopedia.com

British Museum registration numbers

Chapter 1
OA 1945.10-17.261, bequest of Oscar Raphael
 (HT 9.5 cm, DIAM 21.1 cm)
Arabic script
OA 1888.9-1.16 (HT 127 cm)
OA 1921.10-11.4b
 (page dimensions 24.8 x 14.1 cm)
OA 1993.10-9.1 (each page 28.9 x 18.4 cm)
OA 1891.6-23.5 (L 19.7 cm)
OA 1949.4-9.86 (34.2 x 61 cm)
OA 1945.10-17.261
OA 1866.12-69.61 (HT 30 cm)
OA G499 (HT 131 cm)
Geometry
OA 1866.12-69.61
OA 1993.10-9.1
OA 1948.10-9.65 (67.8 x 51.4 cm)
Arabesque
OA 1869.1-20.3 (HT 23 cm, max. W 21.3 cm)
OA 1891.6-23.5
OA G67, Godman bequest
 (HT 27.3 cm, DIAM 42 cm)
OA G66, Godman bequest
 (HT 28 cm, DIAM 42 cm)
Human figure
OA 1948.10-9.69, bequeathed by P. C. Manuk
 Esq. and Miss G. M. Coles through the NACF
 (26.6 x 20.5 cm)
OA 1950.7-25.1 (HT 8.5 cm, DIAM 7.1 cm)
OA 1945.10-17.261
OA 1920.9-17.13(2) (18.1 x 8.9 cm)
OA 1874.3-2.6 & 7, gift of A. W. Franks
 (28 x 2.9 cm & 17.5 x 2.9 cm)
OA 1891.6-23.5
OA 1983.7-27.1 (19 x 12.8 cm)
OA 1948.10-9.69
OA 1997.11-8.1

Chapter 2
OA 1993.10-9.1
OA 1888.9-1.16
OA 1974.6-17.13(16) (20 x 13 cm)

OA 1997.11-8.1 (16.2 x 11.7 cm)
OA 1874.3-2.6 & 7
OA 1960.2-13.1 (14.6 x 8.7 cm)
OA 1937.7-10.330 (17.4 x 9.8 cm)
OA 1964.12-18.1 (L 21 cm)

Chapter 3
OA 2001.5-21.35, anonymous gift (L 35.5 cm)
OA 1948.12-11.23 (31.6 x 20.8 cm)
OA 1891.6-23.5
OA 1950.7-25.1
OA 1938.1-8.2
OA 1920.9-17.5
OA 1983.7-27.1
OA 1950.7-25.1

Chapter 4
OA 1948.12-11.23
OA 1921.10-11.4b
OA 1948.12-11.23
OA1921.10-11.4b
OA 2001.5-21.35
OA 1953.2-14.1, bequest of Sir Edward Marsh,
 KCVO, CB, CMG, through the NACF
 (18.8 x 12 cm)
OA G232b, Godman bequest (DIAM 20.1 cm)
OA G230, 231, 232a & 232b, Godman bequest
OA G232a
OA 1972.4-10.1 (HT 11 cm, DIAM 30 cm)
OA 1920.9-17.5 (27 x 19.4 cm)
OA 1920.9-17.13(2)
OA 1921.10-11.4b
OA G66
OA 1921.10-11.4b
OA 1948.12-11.23
OA 1921.10-11.4b
OA 1953.2-14.1

Chapter 5
OA 1866.12-69.61
OA 1869.1-20.3
OA 1948.10-9.65

OA 1874.3-2.7
OA 1948.10-9.65
OA 1950.7-25.1
OA 1948.10-9.65

Chapter 6
OA 1869.1-20.3
OA 1866.12-69.61

Chapter 7
OA 1866.12-69.61
OA 1891.6-23.5
OA 2001.5-21.35
OA 1866.12-69.61
OA 1950.7-25.1
OA 1934.1-13.1 (41 x 22.2 cm)

Chapter 8
OA 1974.6-17.15(23) (13 x 13 cm)
OA 1869.1-20.3
OA 1950.7-25.1
OA 1891.6-23.5
OA 1950.7-25.1
OA 1866.12-69.61
OA 1950.7-25.1
OA 1974.6-17.15(23)
OA 1866.12-69.61

Chapter 9
OA 1950.7-25.1
OA 1981.6-4.3, Woodward bequest
 (30 x 31 cm)
OA 1950.7-25.1
OA 1959.11-20.1 (HT 6.4 cm, L 19.5 cm)
OA 1948.10-9.69
OA 1866.12-69.61
OA 1930.7-19.63 (DIAM 20.8 cm)
OA 1866.12-69.61
OA 1874.3-2.6
OA 1866.12-69.61

Glossary

arabesque Geometricized scroll with repeating and reciprocating leaf, floral or occasionally figural or zoomorphic elements attached to a vine.

dervish Follower of one of the mystical 'paths' in Islam, centred on the teachings of specific spiritual guides and their followers.

dhikr The repetition of words or phrases to induce concentration on God.

djinn Genie or spirit, created of flame and depicted as a demon; generally negative, but can also be helpful to humans.

furusiyya Literature devoted to the study of horses and horsemanship.

Hadith Traditions of the Prophet Muhammad; after the Qur'an, the most important source of sayings of Muhammad and Muslim religious guidance.

Hajj Muslim pilgrimage to Mecca.

Hijra The migration of Muhammad and a band of companions from Mecca to Madina in AD 622, marking the beginning of the Muslim calendar.

imam Divinely guided leader of the Shi^cat ^cAli (Party of ^cAli), a major Muslim sect.

Ka^cba The cube-like structure in the centre of the courtyard of the Great Mosque in Mecca, the holiest shrine in Islam, towards which all Muslims face when they pray; the Qur'an states that the foundations were laid by Abraham and Isma^cil.

kufic Angular or squared Arabic script.

madrasa Muslim religious college.

muhaqqaq Meaning 'meticulously produced', this majestic rounded script was preferred for copying Qur'ans.

naskh Rounded Arabic script, one of the six styles of writing defined by Ibn Muqla.

nasta^cliq Hanging script, predominantly used for writing in Persian and Urdu from the 16th century onwards.

Qur'an The Muslim holy book as revealed to Muhammad and later written down in Arabic.

raihan Rounded script, closely related to thuluth and muhaqqaq but slightly smaller in scale, one of the six styles of writing defined by Ibn Muqla.

riqa^c More rounded, less angular cursive Arabic script, one of the six styles of writing defined by Ibn Muqla.

sama^c Hearing music which can produce an ecstatic state in the mystical listener.

simurgh Persian mythical bird, resembling a bird with a lion's or dog's head in pre-Islamic times and a phoenix in the Islamic era.

Sufi(sm) Islamic mysticism.

tawqi^c One of the six styles of writing defined by Ibn Muqla, related to riqa^c and thuluth.

thuluth Large-scale Arabic script used in monumental inscriptions.

tughra Calligraphic monogram of the emperors of Ottoman Turkey.

Index

Glossary

arabesque Geometricized scroll with repeating and reciprocating leaf, floral or occasionally figural or zoomorphic elements attached to a vine.

dervish Follower of one of the mystical 'paths' in Islam, centred on the teachings of specific spiritual guides and their followers.

dhikr The repetition of words or phrases to induce concentration on God.

djinn Genie or spirit, created of flame and depicted as a demon; generally negative, but can also be helpful to humans.

furusiyya Literature devoted to the study of horses and horsemanship.

Hadith Traditions of the Prophet Muhammad; after the Qur'an, the most important source of sayings of Muhammad and Muslim religious guidance.

Hajj Muslim pilgrimage to Mecca.

Hijra The migration of Muhammad and a band of companions from Mecca to Madina in AD 622, marking the beginning of the Muslim calendar.

imam Divinely guided leader of the Shiᶜat ᶜAli (Party of ᶜAli), a major Muslim sect.

Kaᶜba The cube-like structure in the centre of the courtyard of the Great Mosque in Mecca, the holiest shrine in Islam, towards which all Muslims face when they pray; the Qur'an states that the foundations were laid by Abraham and Ismaᶜil.

kufic Angular or squared Arabic script.

madrasa Muslim religious college.

muhaqqaq Meaning 'meticulously produced', this majestic rounded script was preferred for copying Qur'ans.

naskh Rounded Arabic script, one of the six styles of writing defined by Ibn Muqla.

nastaᶜliq Hanging script, predominantly used for writing in Persian and Urdu from the 16th century onwards.

Qur'an The Muslim holy book as revealed to Muhammad and later written down in Arabic.

raihan Rounded script, closely related to thuluth and muhaqqaq but slightly smaller in scale, one of the six styles of writing defined by Ibn Muqla.

riqaᶜ More rounded, less angular cursive Arabic script, one of the six styles of writing defined by Ibn Muqla.

samaᶜ Hearing music which can produce an ecstatic state in the mystical listener.

simurgh Persian mythical bird, resembling a bird with a lion's or dog's head in pre-Islamic times and a phoenix in the Islamic era.

Sufi(sm) Islamic mysticism.

tawqiᶜ One of the six styles of writing defined by Ibn Muqla, related to riqaᶜ and thuluth.

thuluth Large-scale Arabic script used in monumental inscriptions.

tughra Calligraphic monogram of the emperors of Ottoman Turkey.

Index